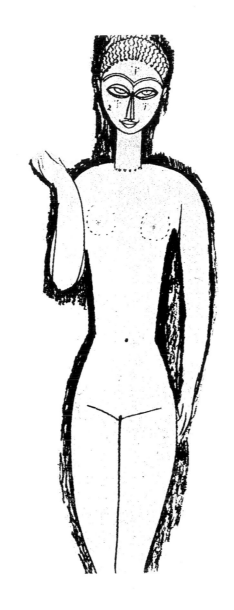

modigliani

Great Modern Masters

Modigliani

General Editor: José María Faerna

Translated from the Spanish by Alberto Curotto

CAMEO/ABRAMS

HARRY N. ABRAMS, INC., PUBLISHERS

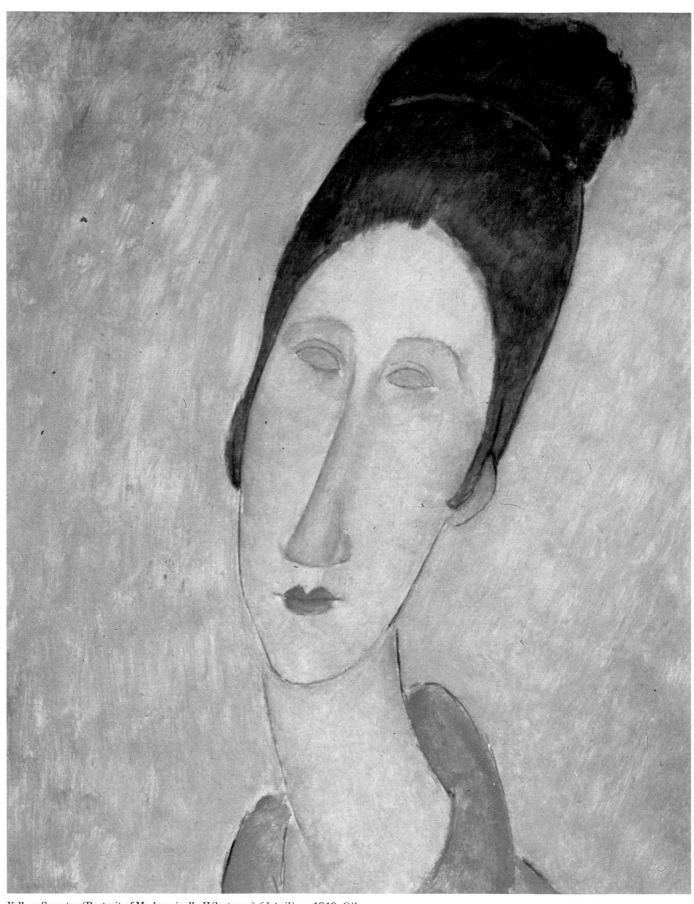

Yellow Sweater (Portrait of Mademoiselle Hébuterne) *(detail), c. 1919. Oil on canvas,*
39 3/8 × 25 5/8" (100 × 65 cm). The Solomon R. Guggenheim Museum, New York

On the Fringes of the Avant-Garde

The art scene during the first two decades of the twentieth century was almost single-handedly shaped by the groundbreaking emergence of avant-garde groups. In this climate, Modigliani was yet an eccentric figure, belonging to what—for lack of a better label—has been called "Ecole de Paris." The only thing the members of this group shared, aside from their physical ties to the French capital—which historian Giulio Carlo Argan once noted served as the center of the international art market rather than the seat of any particular school—was their rejection of academic impositions, as well as a common aspiration toward modernity, a goal rooted in the intellectual and aesthetic premises set forth by the artistic movements of the late nineteenth century. It was in this cosmopolitan setting, frequented by artists from every corner of the world, that Modigliani would develop his own peculiar style, and his works—like those of Marc Chagall or Constantin Brancusi—are proof that, in 1915, it was quite possible to be a modern artist without being enlisted in any particular avant-garde movement.

Creative Freedom

Modigliani did not share the strong associative drive of his contemporaries. His own relationships with other artists—such as Utrillo, Soutine, Foujita, and Kisling—were not based on a sense of aesthetic affinities as much as on close personal friendships. His well-known refusal to accept painter Gino Severini's invitation to endorse the first Futurist manifesto in 1909 was not motivated simply by his independent ambitions, but rather by his own strong ties with tradition. For the Italian artist, the iconoclastic rants of his countrymen—whose scorn for art would eventually lead them to advocate, among other things, the destruction of all museums—could only induce contempt. From the outset—with an attitude inherited from his Macchiaioli teachers—Modigliani rejected all academic influences, resolving to assert his own creative freedom and autonomy.

Between Past and Future

The Parisian lifestyle had a modernizing effect on Modigliani's artistic evolution through a number of different influences, from his awareness early on of Toulouse-Lautrec's and Paul Gauguin's emphasis on the decorative aspect, to the chromatic revolution launched by the Fauvists as a result of Paul Cézanne's crucial insights into the constructive value of colors. Nonetheless, Modigliani's works would continue to display traditional references. His production bespeaks the inspiration of Italian trecento artists—such as Simone Martini and Tino di Camaino—as well as of the art of ancient Egypt and of archaic and primitive civilizations, which by then were beginning to be studied throughout Europe. Modigliani's relationship with ancient art was far from nostalgic; rather it was grounded in the harmonious application of artistic procedures. Like the Khmer artist or the Egyptian sculptor, Modigliani filtered data through a process of abstraction—in the literal sense—capturing the essence of the motif through his own subjectivity and poetic nature. This method required the artist to establish an emotional connection with his model, a type of focus that excluded all physical surroundings in the studio, and yet was likely to last only until the end of any one sitting. This may well be the reason why, for

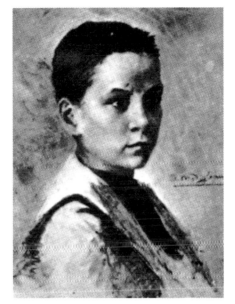

"Dédo," as his parents used to call Amedeo, executed this surprisingly expressive self-portrait when he was only fifteen. In this charcoal drawing he timidly approximates the "dash of color" (macchia) technique typical of the Macchiaioli, a group of Tuscan painters whose work foreshadowed some of the key elements of Impressionism.

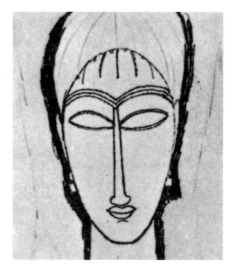

Modigliani's portraits and sculptures drew inspiration from the stylized and schematized forms of the art of primitive civilizations.

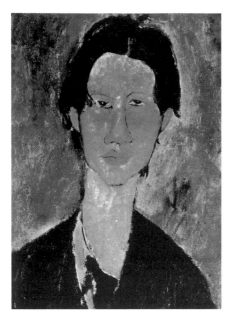

Portrait of Chaïm Soutine (detail), 1916. The Lithuanian-born artist Chaïm Soutine was a contemporary of Modigliani. They became close friends and were also bound by certain artistic affinities.

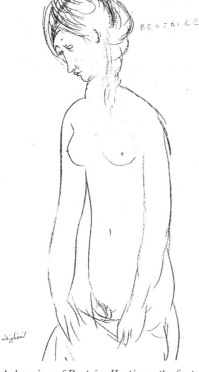

A drawing of Beatrice Hastings, the first woman with whom Modigliani was romantically involved. Hastings was a British poet and writer who had also performed as a horsewoman in a South African circus.

the most part, Modigliani painted his works in one day without interruption. Modigliani was receptive to the varied stimuli generated by the many avant-garde groups of the time, and this, along with his desire to reconcile these novel approaches with his traditional leanings, made him a precursor to the spirit that animates some of the artistic currents of today. While the avant-garde movement may be officially defunct, it aided in formulating new, partial, and nonexclusive readings of the modern tradition. Poised as he was between past and future—a peculiar condition to which French poet Guillaume Apollinaire had drawn attention early on—Modigliani's work therefore possesses a timeless quality, one that actually prevented its public recognition and success in an age when novelty was becoming in itself a quality of tantamount importance. By the same token, however, the subtle elegance and seemingly monotonous quality of his work, with its delicate refinement, was bound to become the very key to its later success.

A Romantic Artist

The popularity enjoyed by Modigliani's work posthumously has no doubt been bolstered by the myth surrounding the artist, a myth that the painter himself helped to create and that was further enhanced by his untimely death. A man of impressive good looks and countless lovers, passionate and defiant and yet hampered by illness, Amedeo fits perfectly into the role of the Romantic artist. According to a description by Jean Cocteau, "a dark fire kindled his entire being, radiating through the fabric of his clothes and conferring on his slovenly figure a certain dandyish air. He was joyful, witty and charming." Some of his contemporaries, though, felt that his attitude smacked of the poseur. Ever the caustic wit, Pablo Picasso—for whom Modigliani held a profound but unrequited admiration—is said to have expressed surprise at the fact that the Italian artist made a scene with his alcoholic ravings only where they would most likely be noticed: on the corner of boulevards Montparnasse and Raspail, at the very heart of the Parisian artistic bohemia. Whether he was posing or not, Modigliani's attitude was fostered as a young man, when his readings of Friedrich Nietzsche and Gabriele D'Annunzio had persuaded him of the exceptional nature of the creative artist: an individual—as Modigliani once wrote to his friend Oscar Ghiglia—who, in view of his different needs, is entitled to special rights unlike those of other mortals.

A Distant Melancholy

Ironically, Modigliani's underlying elitism, which focused its distaste on the bourgeoisie, was nurtured along with his profound responsiveness to the plight of the human condition, as evidenced by a statement inscribed on one of his drawings: "Life is a gift / from the few to the many / from those who know and who have, to those who know not and have not." Even though he had seemingly chosen to live a poor existence—indeed, his mother gave him money throughout most of his life—Modigliani nonetheless suffered severely from his lung illness and was certainly not indifferent to the lack of recognition his work received. Despite such vicissitudes, however, his artistic production remained impervious to the slovenly aspects of his existence and firmly rooted in its delicate, melancholy world.

Amedeo Modigliani / 1884–1920

Amedeo Modigliani was born in 1884 in the Tuscan city of Livorno (also known as Leghorn) to a relatively well-to-do family of Sephardic Jews. He was the youngest of four brothers, the eldest of whom, Emmanuel, was destined to become a prominent leader of the Italian Socialist Party. Their parents were Flaminio Modigliani, a businessman of Roman origins, and Eugenia Garsin, an educated and open-minded woman who played an extremely influential role in shaping the character of the young Amedeo.

Two events occurred in his early life that were to permanently influence him thereafter. At age fourteen, he contracted a serious case of scarlet fever, from which he never fully recovered, and then two years later he began, with his mother's consent, to take drawing lessons. In her diary, Eugenia confessed that she saw in this activity a way for her son to overcome the "listlessness" resulting from his illness. Modigliani was fortunate in that unlike most of his bourgeois colleagues, he never met with his family's antagonism regarding his artistic pursuits.

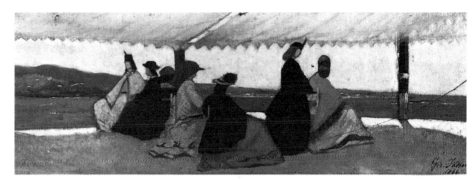

Giovanni Fattori, The Palmieri Rotunda, *1866. Modigliani discovered Fattori through the latter's pupil, Micheli, who, like his teacher, was torn between a more Romantic style and the realism of the "dash of color" technique practiced by the Macchiaioli school, to which both painters belonged.*

Art Fever

In 1898, Modigliani gave up his regular course of studies and began to frequent the studio of Guglielmo Micheli, a pupil of Giovanni Fattori's and, like the latter, a follower of the Macchiaioli—a group of painters from Tuscany whose "dash of color" technique foreshadowed certain aspects of Impressionism. During the winter of 1901, Modigliani came down with tuberculosis and, in pursuit of a warmer climate, traveled to the south of Italy with his mother. The journey enabled him to experience firsthand the great works of Italian art, rekindling and confirming his desire to become an artist. In 1902 he enrolled at the Accademia di Belle Arti (Scuola Libera di Nudo) in Florence and, the following year, at the Instituto di Belle Arti in Venice. There Modigliani met the Chilean painter Ortiz de Zárate (who would eventually become his neighbor in Paris), to whom he confided his desire to become a sculptor. It was arguably here in Venice that Modigliani, emancipated from his family's protection, first began to lead a bohemian lifestyle, attending occultist séances and using hashish. These Venetian years can be viewed as a rehearsal for his trip to Paris, where he arrived early in 1906, and where he rented a studio on the rue Caulaincourt in the district of Montmartre. Soon thereafter he enrolled at the Colarossi Academy and began to carve stone sculptures, obtaining the necessary materials—rather hazardously—from a number of Parisian construction sites. Always neatly groomed in his velvet suit and scarlet scarf, Modigliani plunged into a city that was then experiencing its zenith as an art center: the Fauvists had recently caused a sensation at the Salon d'Automne of 1905, and Picasso was already working on his *Demoiselles d'Avignon*, the revolutionary painting destined to become the seed of Cubism.

A Bohemian in Paris

Even though the Italian artist early on became one of the most distinctive representatives of the city's bohemia, he always remained on the margins of any more or less organized movement. In 1907 he met the man who would become his first mentor in Paris: Paul Alexandre, a physician who

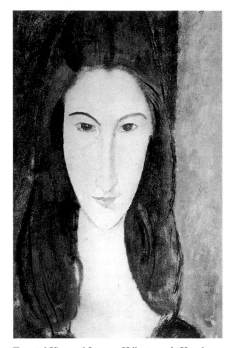

Frontal View of Jeanne Hébuterne's Head, *1918. The beautiful Jeanne Hébuterne was Modigliani's companion for the last three years of their lives, during which she bore him his only acknowledged child. Their daughter, also named Jeanne, is the author of two books devoted to her father's work.*

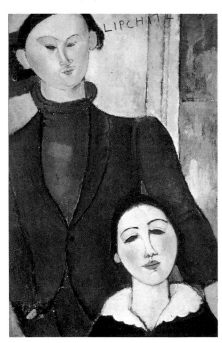

Portrait of Jacques Lipchitz and His Wife, *1916–17. The Italian artist had a lifelong association with sculpture. In this painting, Modigliani has portrayed the famous Lithuanian-born sculptor Jacques Lipchitz, one of his friends from the Parisian bohemia.*

had established a small community of artists in a squatter building on the rue Delta. The following year, Alexandre persuaded Modigliani to show some of his works at the Salon des Artistes Indépendants. While all six paintings seemed predominantly influenced by Cézanne, Modigliani's work through the end of the decade also showed signs of Toulouse-Lautrec, Gauguin, and Picasso's Blue Period.

Sculpture

In addition to Dr. Alexandre, the other most influential figure in the development of Modigliani's artistic career was his neighbor at the Cité Falguière in Montparnasse, the Romanian sculptor Constantin Brancusi. Modigliani had never really given up on his desire to become a sculptor, so in 1909, he decided to devote himself entirely to this artistic medium. His works from this period, which lasted until 1914, were done in the stone-cutting method and resulted from a process of stylization heavily indebted to African art—a subject of profound fascination for most avant-garde artists of that time—as well as to the statuary of both ancient Egypt and archaic Greece. In 1912 his friends, appalled by the painter's deplorable living conditions, decided to chip in and collect enough money to send him home, hoping that in a more familiar environment he would amend his bohemian habits. Thus, in the summer of that year, Modigliani traveled for the last time back to Livorno, in his native Italy, where he was soon able to locate a studio and resume sculpting. According to some unconfirmed biographical lore, the criticism of his friends toward his work may have induced the artist to fling his own sculptures into a local canal (known as the Scali Olandesi), which to this day have never been recovered. This trauma, together with the lack of a studio better fit for carving stone, and the detrimental health effects that breathing stone dust had on his weak lungs led Modigliani to give up working in sculpture once and for all. Nevertheless, this phase of the artist's career was characterized by intense exercises in synthesis that left their mark on his later production. In 1914, at the outbreak of World War I, Modigliani's failure to enlist in the army because of his delicate health allowed him to resume painting with a renewed vigor. His Parisian friends continued to be the main supporters of his work, among them the art dealer Paul Guillaume, who bought some of his paintings and replaced Dr. Paul Alexandre as a mentor when the latter left to fight in the war; the British poet from South Africa Beatrice Hastings, with whom the painter had a troubled romantic relationship; and, above all, Leopold Zborowski, a Polish poet who in 1917 became both Modigliani's close friend and art dealer.

A Tragic Ending

Modigliani's first solo show, held at the Berthe Weill gallery in December 1917, was closed down by the police on account of some nude paintings—deemed immoral—that were on display in the gallery window. Not a single work was sold. That same year Modigliani met Jeanne Hébuterne, a nineteen-year-old woman who would become his last companion and who bore the painter's only acknowledged child, also named Jeanne. During that period, when the artist's works finally, albeit slowly, began to sell, his health took a turn for the worse, and he became increasingly addicted to drugs and alcohol. In 1920, wasted by kidney disease and tuberculosis and after a week of suffering—during which the couple never left the painter's studio, nor sought assistance from the outside world—Modigliani died in a Parisian hospital. Within a few hours, Jeanne, who was already in the ninth month of her second pregnancy, committed suicide by jumping from the window of her apartment.

Plates

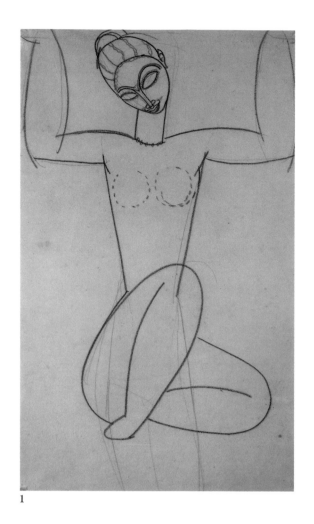

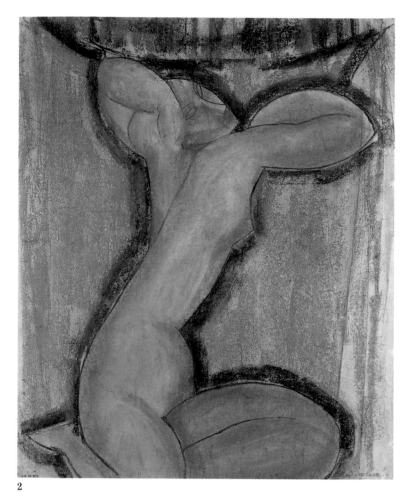

1

2

Sculpture

The extraordinary quality of Modigliani's twenty-five surviving sculptures makes it difficult to speak of his "thwarted ambition," as the Italian artist undoubtedly had a tremendous desire to express himself in this medium to a far greater extent than he actually did. According to Ortiz de Zárate, as early as 1902 Modigliani had confessed to him that he "painted only for lack of something better," since he continued to harbor strong aspirations of becoming a sculptor. With this in mind, it is quite surprising that Modigliani never considered any sculptural technique other than stone-cutting, which was most certainly contraindicated for someone who suffered from a chronic lung condition, and for whom the fine limestone dust must have been intolerable. In the beginning, these circumstances, compounded by the high cost of the materials and the scarcity of clients, kept the artist from devoting himself entirely to sculpture until about 1909, when he met Constantin Brancusi. The Romanian sculptor validated Modigliani's conviction in the superiority of carving directly into the stone and introduced him to the stylized forms of primitive civilizations, which Modigliani aptly harmonized with his own early passion for Egyptian and medieval statuary.

1 Seated Caryatid, *c. 1911. Modigliani's contact with primitive art was bound to leave a significant mark on his work, especially his concept of drawing: the chiaroscuro technique gave way to a supremacy of lines, which then became the dominant elements in compositions marked by extreme synthesis. In this drawing, in a Primitivist vein, the figure's features betray the direct influence of the Romanian sculptor Brancusi.*

2, 3 Caryatid, *c. 1911; Rose Caryatid with a Blue Border, c. 1913. Modigliani's involvement with sculpture yielded a limited number of actual three-dimensional pieces but a far greater quantity of prepatory sketches that, for the most part, bear the common title of "Caryatid." Indeed, they are preliminary studies for works that were meant to be incorporated into architectural structures, and their function as supporting elements justifies the figures'* contrapposto, *or contorted posture, that is equally reminiscent of Khmer temples and of Michelangelo's* serpentinata *forms.*

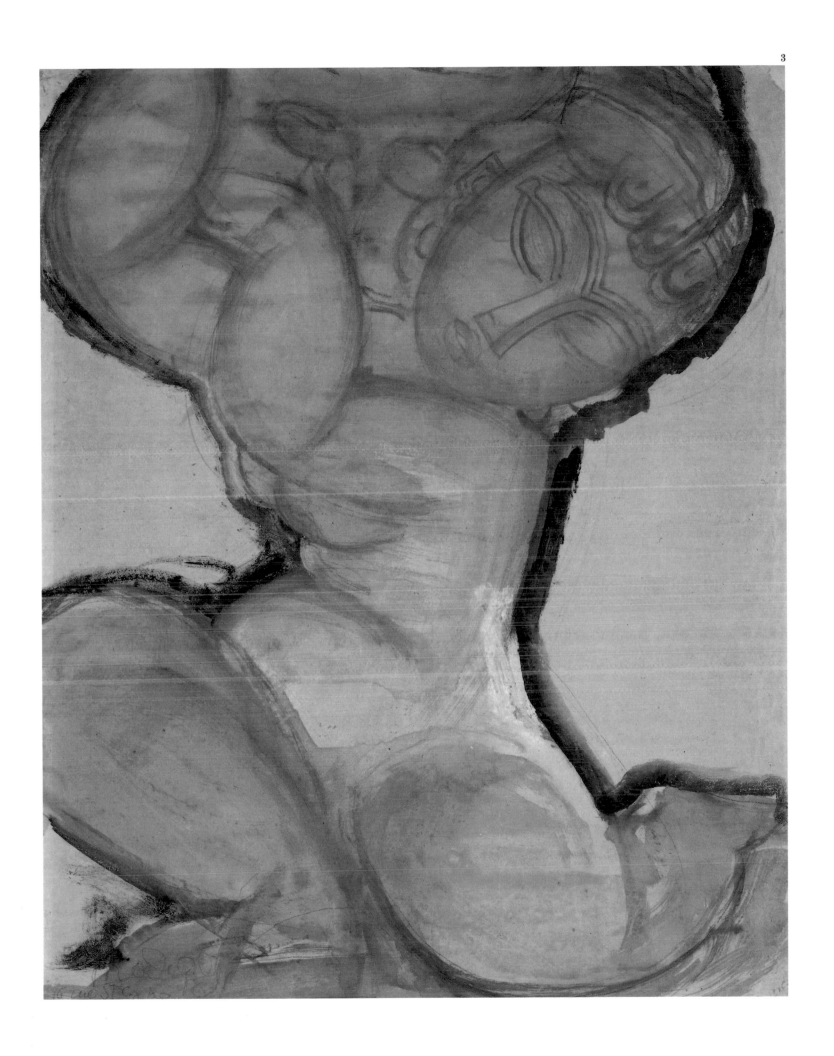

4, 5 Head of a Woman,
*c. 1911–12; Head, c. 1914.
Modigliani's sculptures
are the products of a
creative process of
synthesis. In view of his
aesthetic quest for the
essence of forms, it is
possible that the Italian
artist was strongly
indebted to primitive art
forms, as well as to the
statuary of ancient Egypt,
the Cyclades, preclassical
Greece, and Romanesque
sculpture. The simplicity
of his style, however, has
favored the proliferation
of counterfeits. The most
notable are the forgeries
executed in 1984 by a
group of students who
claimed that they had
recovered the "lost"
sculptures Modigliani had
supposedly thrown into a
canal in Livorno. They
succeeded in convincing
most art critics of the
authenticity of their
discovery, and the farce
continued until the
authors of the fakes
voluntarily confessed to
their deeds.*

4

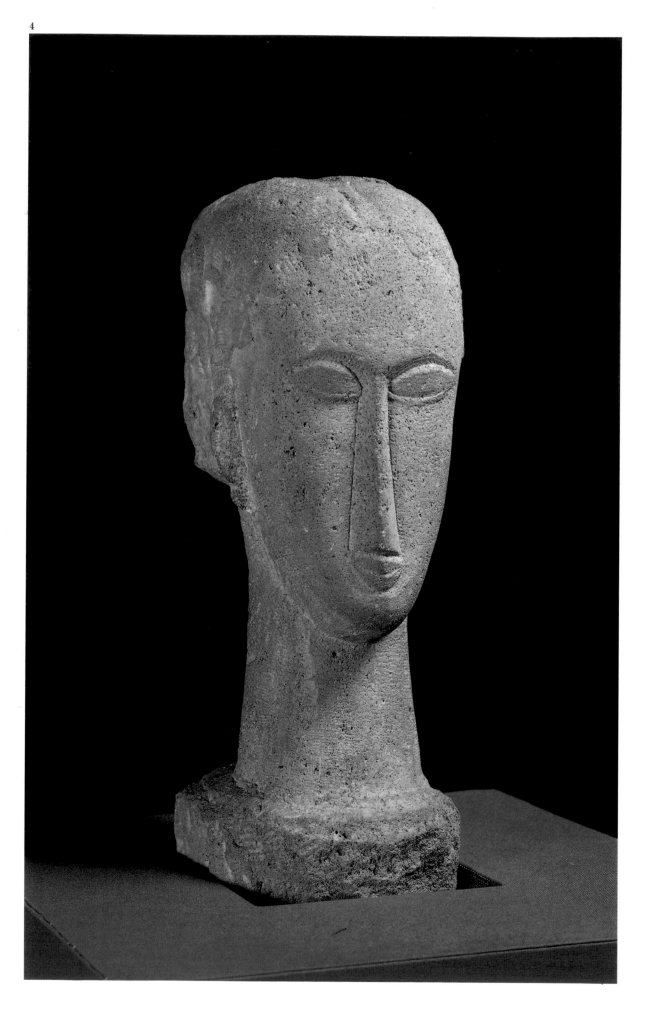

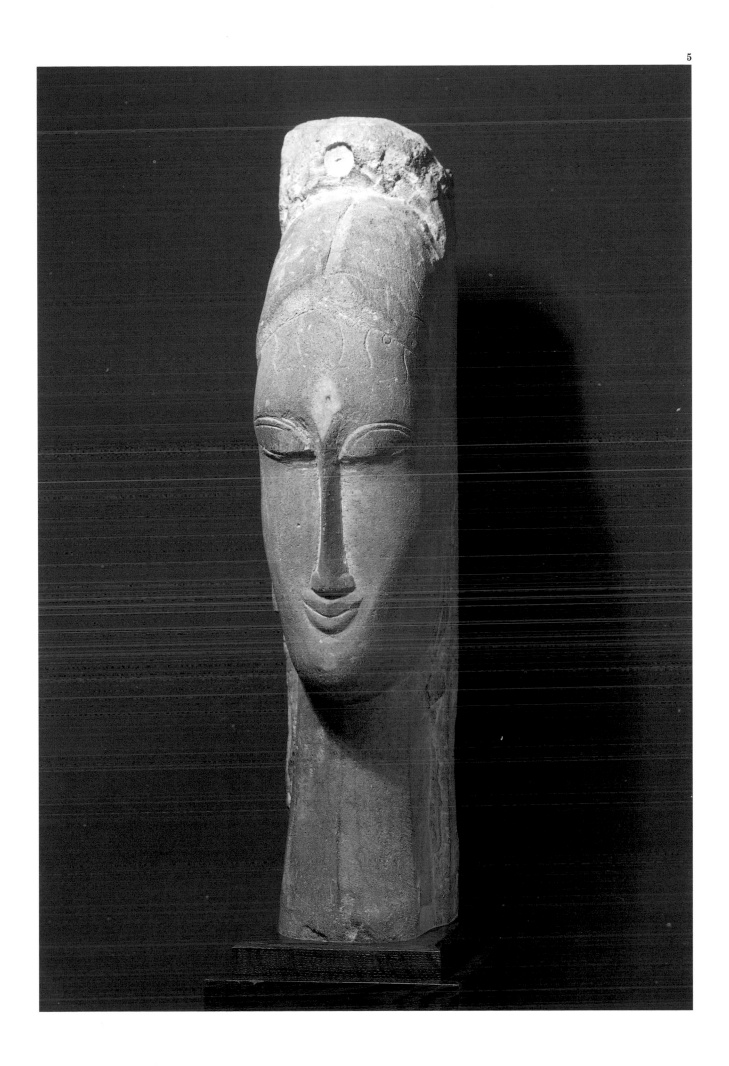

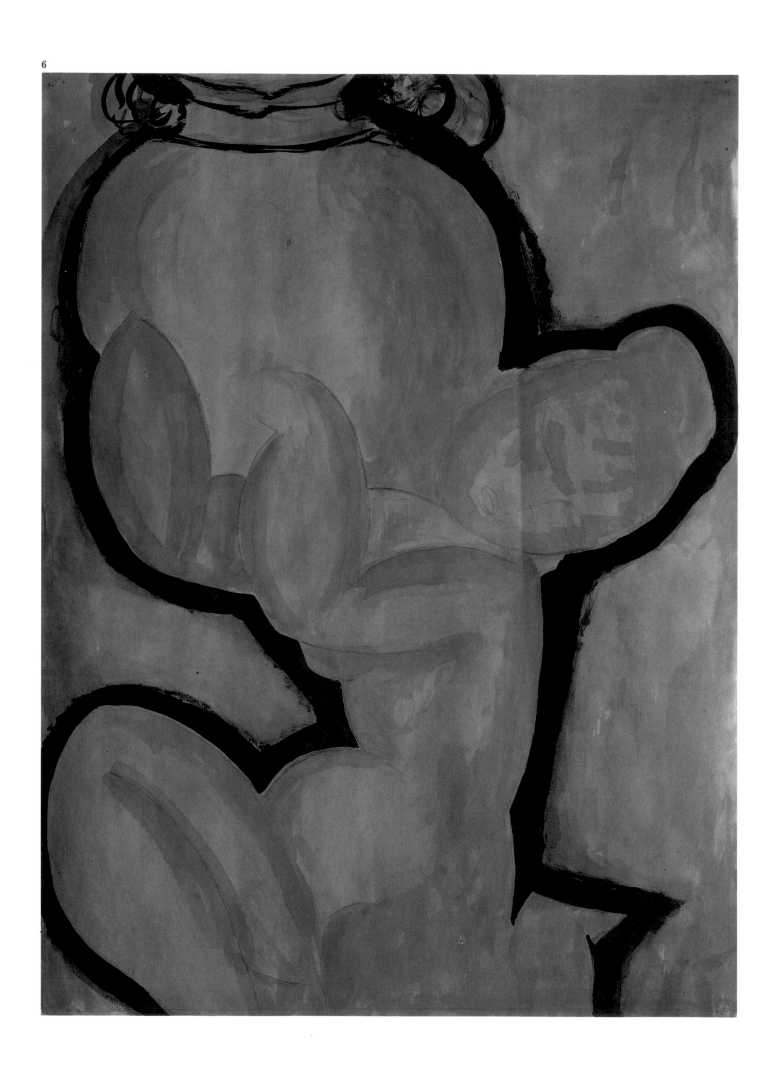

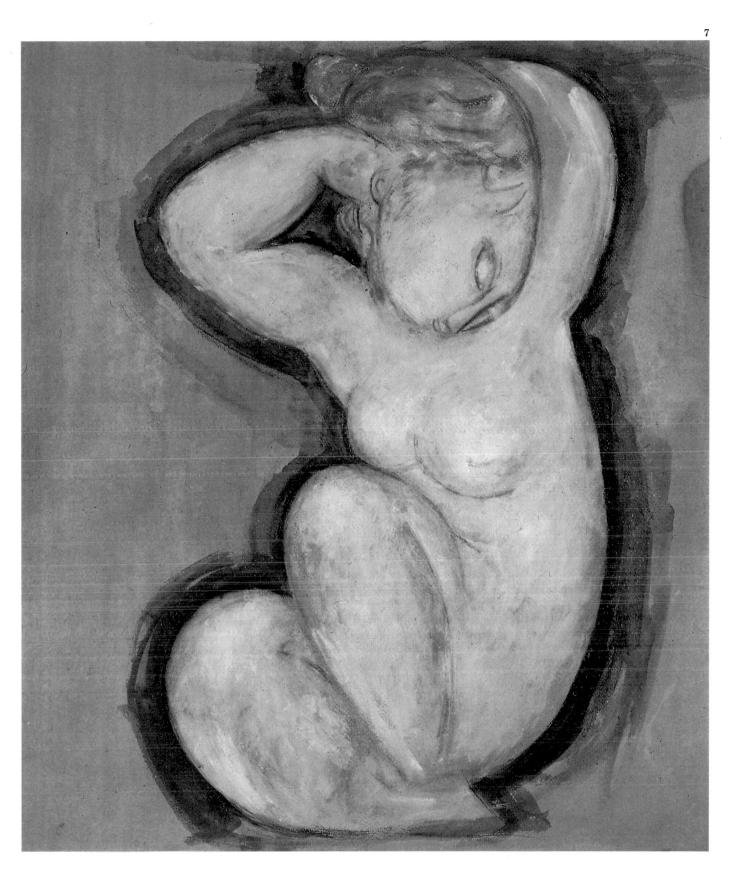

6, 7 Caryatid, *c. 1913–14;* Caryatid, *c. 1913–14. Modigliani's caryatids—only one of which was actually sculpted in stone—were meant to be, in the artist's own words, "the pillars of tenderness" of some utopian "Temple of Beauty." A temple that, as Paul Guillaume once stated, would rise "to the glory of Man rather than God, and would be crowned by hundreds of columns."*

The Quest for a Personal Language

Modigliani's most distinctive and well known works belong to a very brief period of his short career, from 1916 to 1920. Before then, the technique of the Tuscan artist had experienced a number of different influences and undergone substantial changes. Modigliani arrived in Paris in 1906, and none of his early work survives, except a charcoal self-portrait—executed at age fifteen—which though technically rather conventional, is evidence of his early command of draftsmanship. Ortiz de Zárate, a Chilean painter who had met Modigliani in Venice in 1903, asserted that, in those years, the production of the young Italian artist still had a rather academic flavor. It was Modigliani's discovery of modern art that would eventually bring about a profound transformation in his own painting. The concurrent influences of Gauguin, Toulouse-Lautrec, Picasso, and Cézanne are traditionally mentioned when examining Modigliani's evolution as a painter; in fact, for a relatively extended period, he alternated between all of these masters, but always from an individual perspective. Indeed, the coherence of Modigliani's artistic development contradicts certain statements made about his career, such as André Salmon's claim that the Italian painter's transformation from "diligent dauber" to "inspired vagabond" occurred overnight.

8

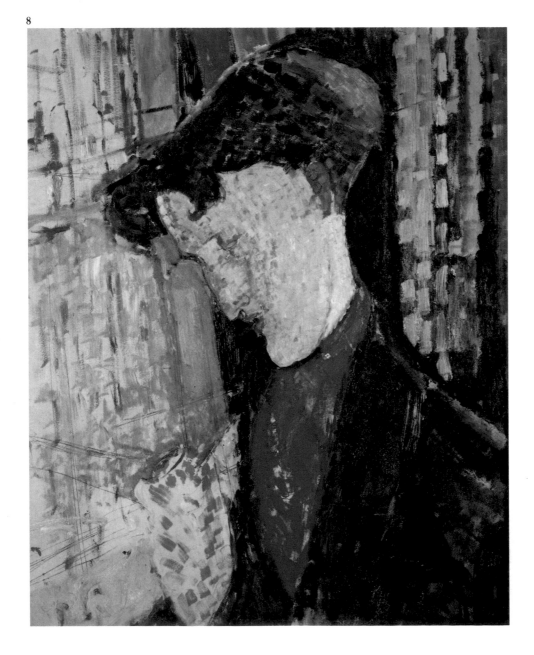

8 Portrait of Frank Burty Haviland, *1914. Modigliani's definitive portrait of Diego Rivera, along with this portrait of the English collector Frank Haviland, are the only two surviving examples of his use of a Divisionist technique. The brushwork is fragmented, producing in some portions of the painting a discernible pattern. However, the intuitive nature of his work is altogether alien to a systematic application of the Divisionist principles of simultaneous contrast and optical chromatic blend.*

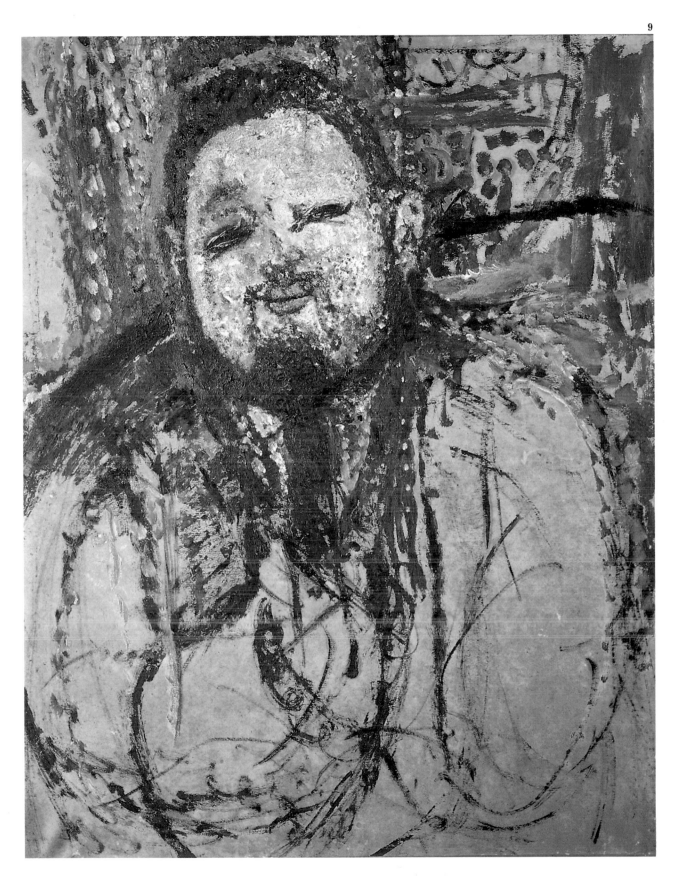

9 Preliminary Study for the Portrait of Diego Rivera, *1914. At this time, the Mexican painter Diego Rivera was one of the most distinctive figures in the Parisian bohemia. A fierce polemicist and a hard drinker, Rivera could often be seen at a table in the café La Rotonde in the company of such well-known personalities as Leon Trotsky. Modigliani portrays his exuberant crony with a peculiar blend of Pointillist brushwork and more relaxed strokes, highlighting the sketchlike nature of this work.*

10 Antonia, *1915. As if in a rigorous application of Cézanne's maxim, Modigliani constructed this figure from two basic geometric shapes: the cylinder and the sphere. Yet, more than in the work of Cézanne, the key to understanding this type of image can be found in African art, which had a strong influence on Modigliani's work in the period when he had taken up sculpture.*

11 Head of a Young Woman, *1915. Albeit rough, this sketch reveals essential elements in the artist's production in the years immediately following his interlude as a sculptor. The spherical triangle of the head is outlined by a thick black stroke, which is also used to delineate the asymmetrical features of the face, particularly the eyes and the nose, while the mouth is rendered as a diminutive spot of deep red. As in many of Modigliani's portraits (see plates 10 and 15), there are two intersecting axes at the head's center.*

10

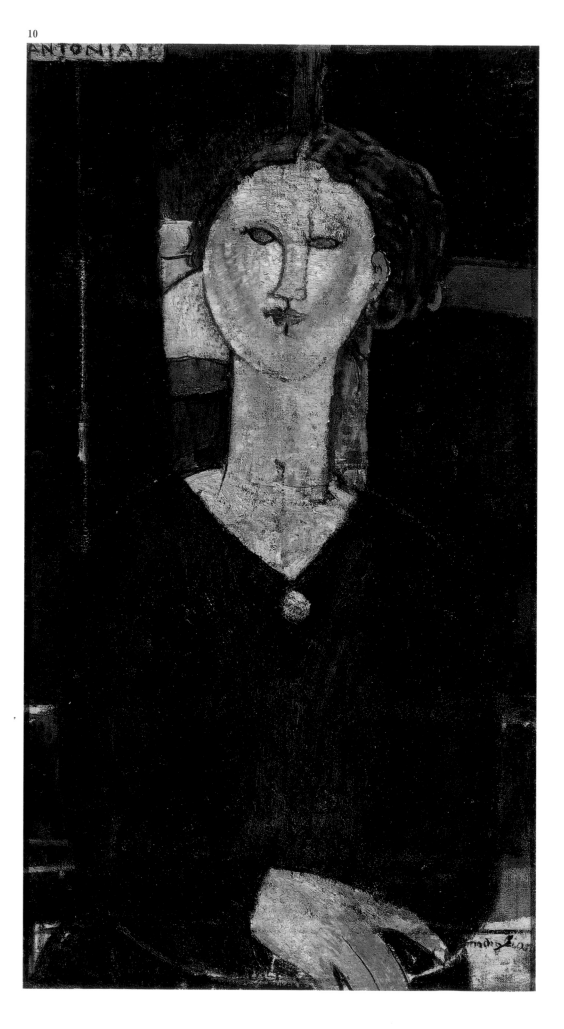

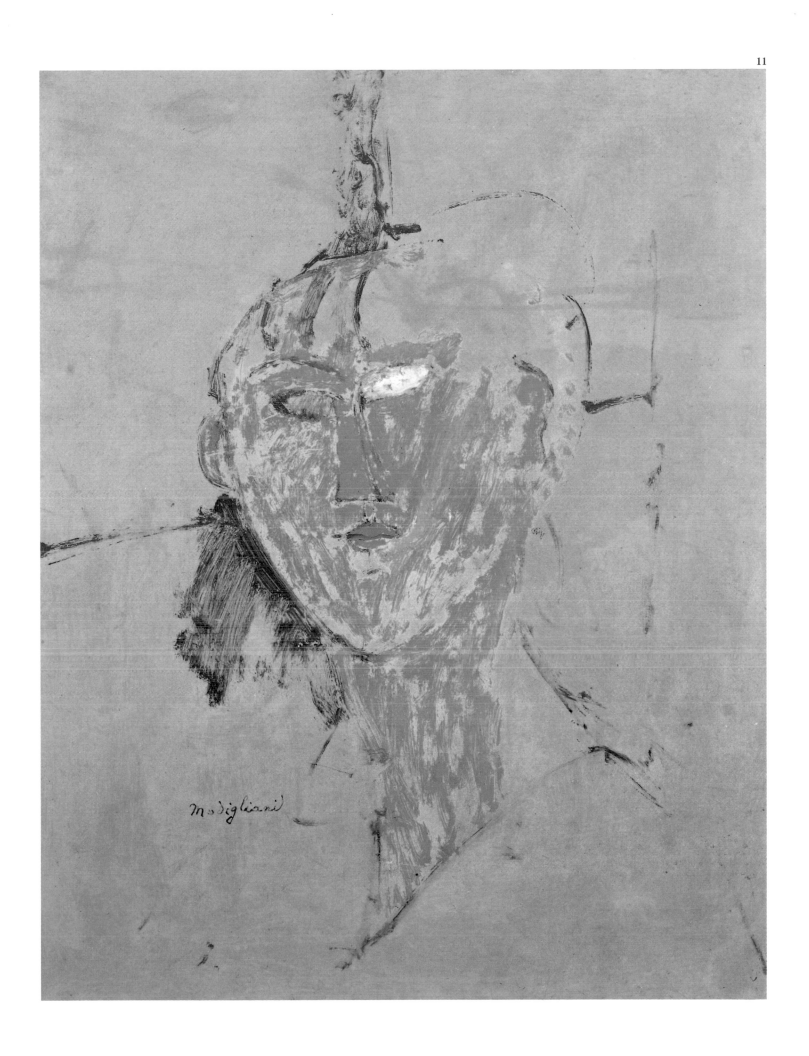

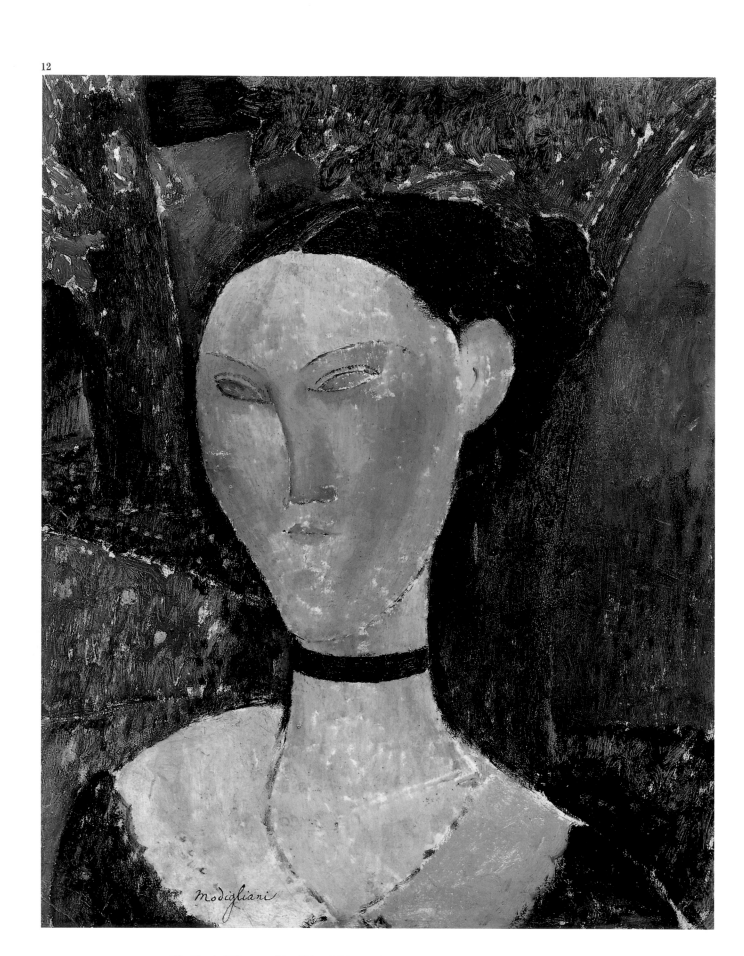

12 Head of Woman with a Velvet Ribbon, *1915. This work is exceptional in two respects: first, the sitter is portrayed in an outdoor, organic environment rather than an interior one; second, the treatment of that natural background is reminiscent of a tapestry with clearly defined fields of color, much in the manner of the "brickwork" typically found in works by Gauguin and the artists of the Pont-Aven group.*

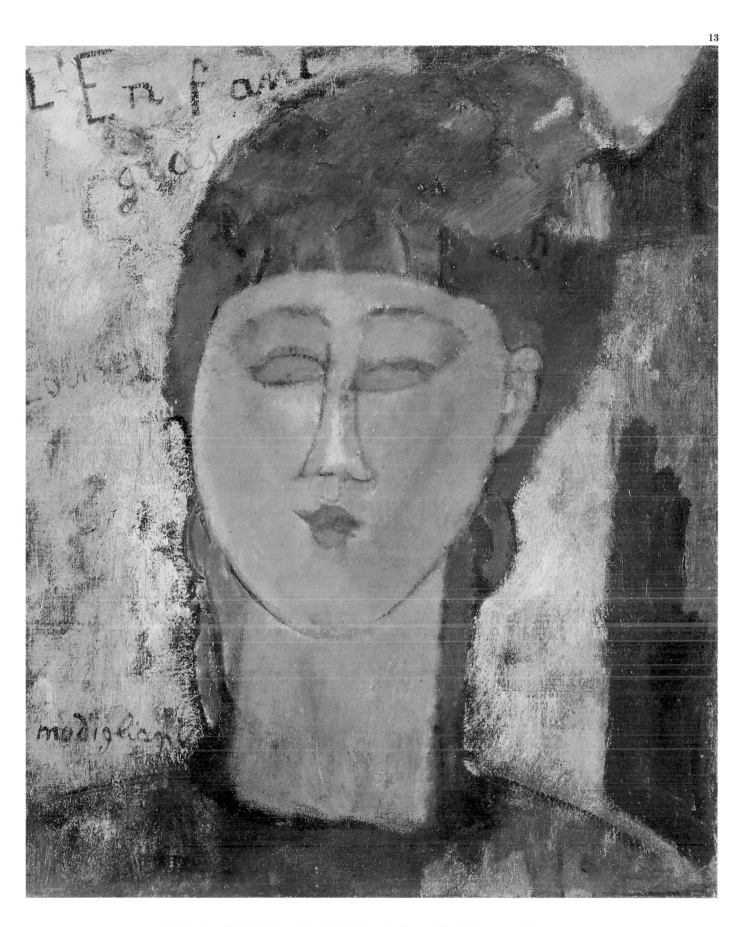

13 The Fat Child *(L'Enfant Gras), 1915. The title is inscribed in the upper left corner of the painting. This stratagem, of Cubist derivation, enabled Modigliani to deter any illusionistic interpretation of the work, while at the same time underscoring its autonomy as a self-contained object that is no less real than the physical world to which it refers.*

14

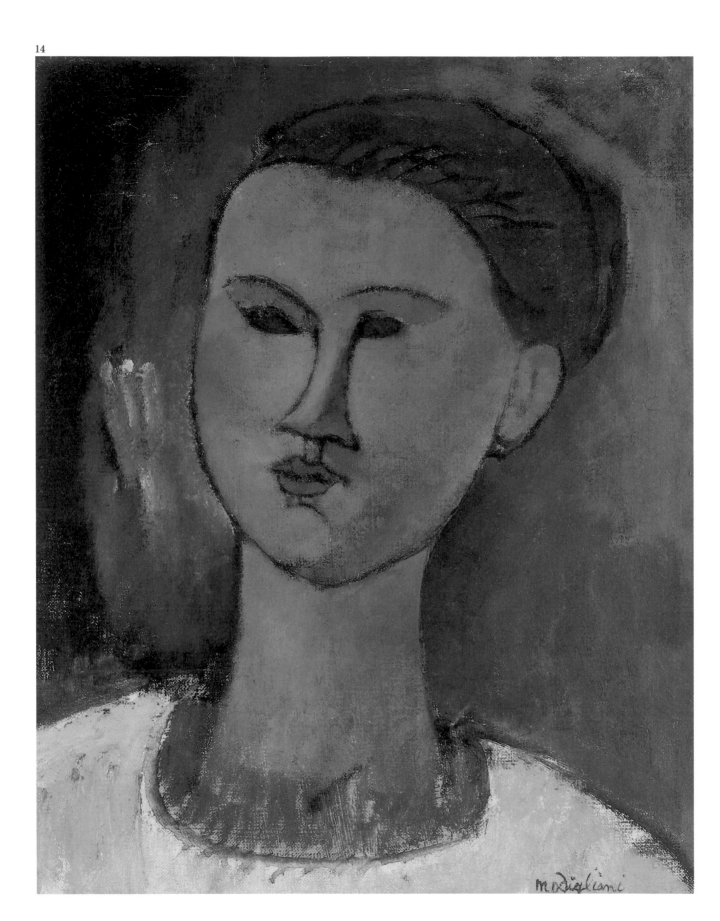

14 Head of a Woman, *1915. This work evokes the process of synthesis Modigliani employed to create his figures after his stint as a sculptor. This manner of creation was heavily indebted to the art of primitive civilizations and, more directly, to Picasso. The distorted features of the girl's face, analyzed from different viewpoints, are reminiscent of the Spanish artist's bold treatment of the human figure in his painting* Les Demoiselles d'Avignon.

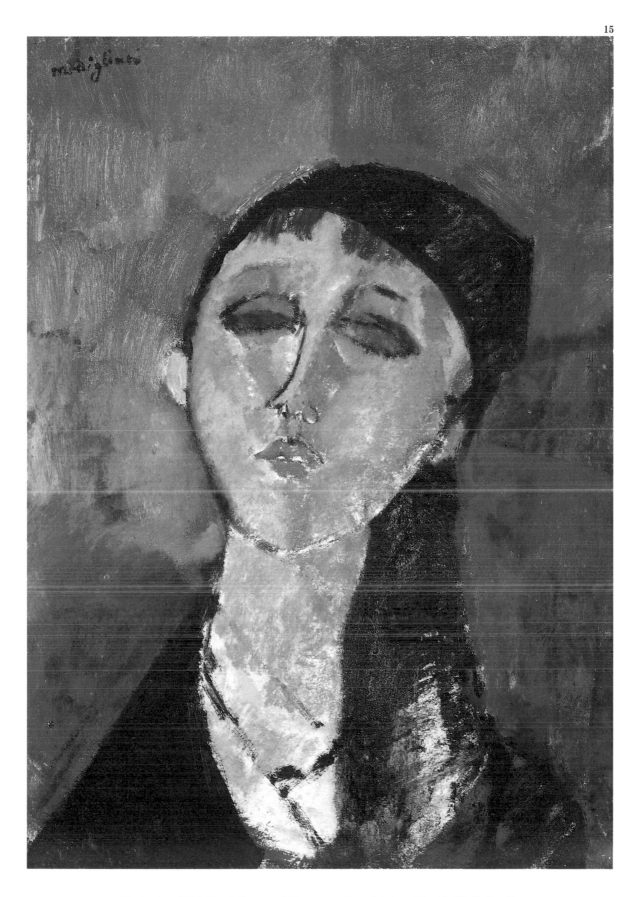

15

15 Louise, *1915. The influence of Cézanne continued to be evident in Modigliani's works through the mid-1910s. Like the older master, Modigliani applied paint to the pictorial surface in a constructive manner, achieving a volumetric sensation by the juxtaposition of tiny spots of color. In this case, however, there are some other elements that are typically Modigliani's, such as the portrayal of the tilted head, the large vacant eyes, and the small, sensual mouth. All of this combines to invest this humble model with a distinctive air of acquiescence.*

Faces

As one of his biographers pointed out, Modigliani's entire career was really a lifelong inquiry into the human figure. With the exception of four landscapes painted early in his career during a trip to the South of France—by the artist's own admission, "the work of a novice"—the human likeness is the only motif that really commanded his attention. Modigliani's portraits, executed for the most part in a single sitting, resulted from an intensely reflective process, requiring a strong emotional connection between the painter and his models. The latter were generally his friends or companions in misfortune, such as young apprentices, maids, and prostitutes. The portraits all share the same air of submissiveness, which most likely resulted not from the artist's alleged faith in the socialist doctrine of his brother, Emmanuel—as some critics have suggested—but rather from a sentimental affinity with the sitter. Most of these works share one peculiar element: the eye sockets are empty and uniformly colored, with no iris or pupil. Léopold Survage, unsettled by the portrait showing him with one normal eye and one dark, void socket, questioned the significance of such an anomaly, to which Modigliani replied: "With one eye you are looking at the outside world, while with the other you are looking within yourself."

16

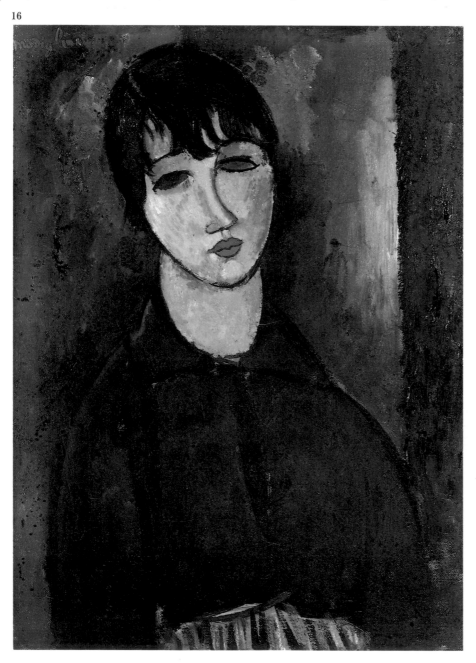

16 The Servant, *1916. Modigliani has depicted this domestic woman's humble existence with a sobriety that contradicts the better-known sensuality of his nudes. The young woman's body almost blends into the cold tonalities of her surroundings, while the blue shadow on her face—somewhat reminiscent of Cézanne—only enhances her expression of a resigned melancholy.*

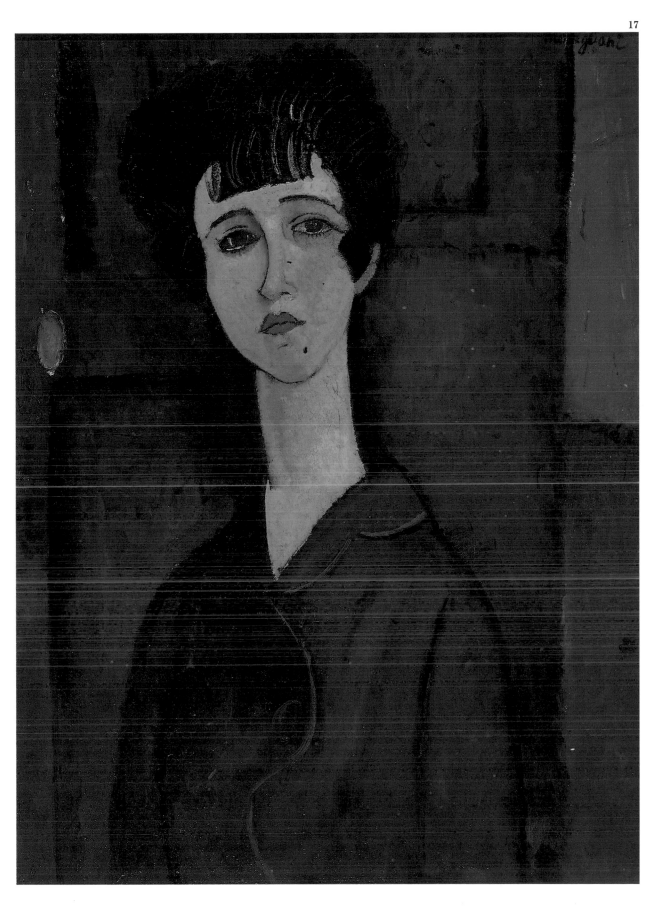

17 Portrait of a Young Woman (Victoria), *1916. The portraits Modigliani painted during this short period are unusual in that in them he made an exceptional effort to accurately define the features of each sitter, hence the "conventional" representation of the model's eyes with clearly depicted pupils.*

18 Man in a Hat, *1916. This painting clearly illustrates a consistent feature in Modigliani's production, namely the depiction of two different angles within the same portrait, showing how the frontal pose of the sitter's body melds with the lateral view of the same model's facial features. This intellectualized notion of anatomy is prevalent in primitive art and was given its ultimate expression by the Cubists.*

18

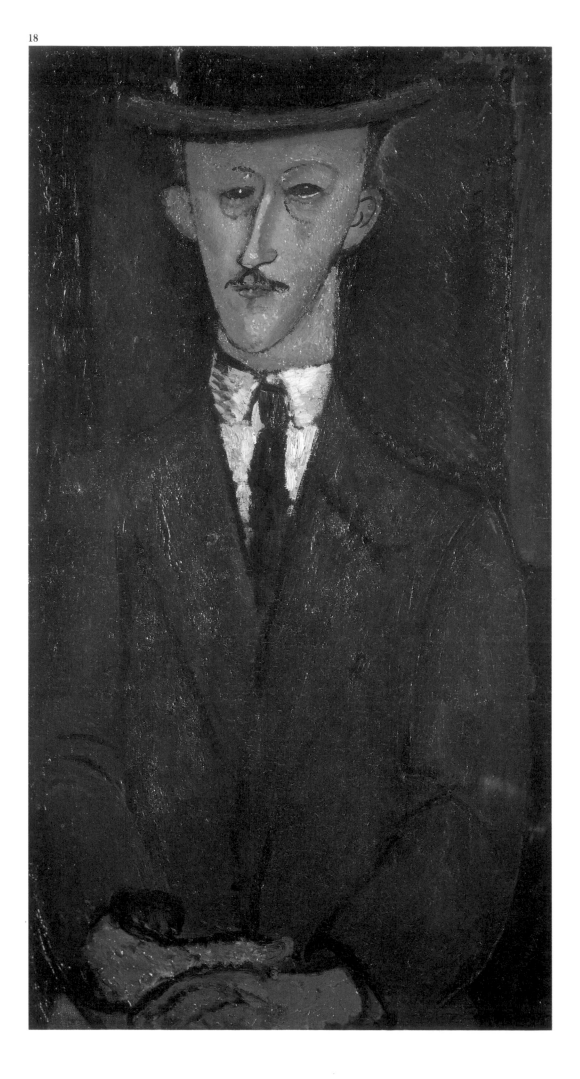

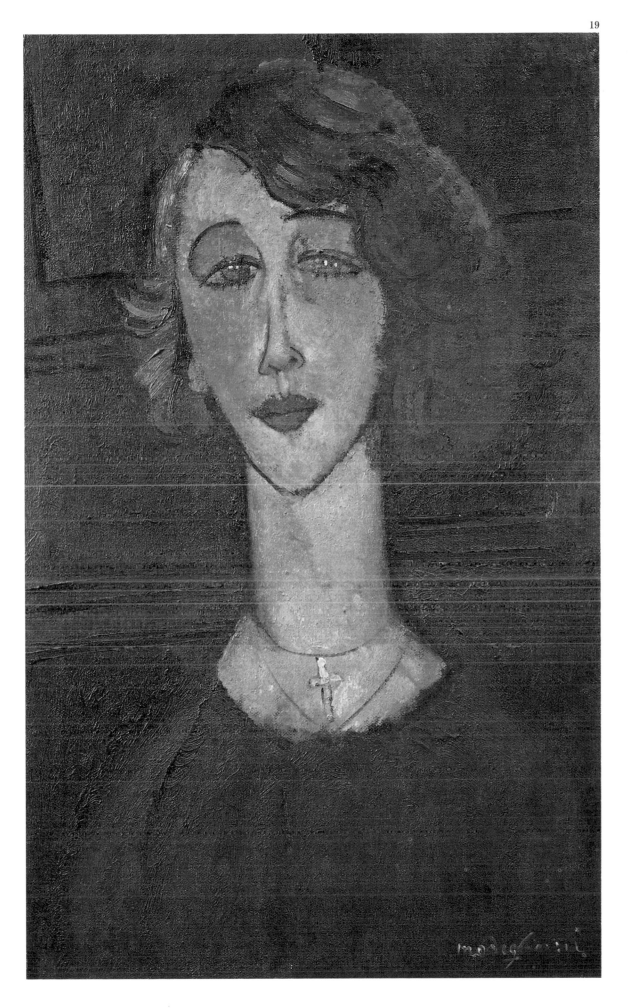

20 Head of a Woman in a Hat (Lolotte), *c. 1916. The lighthearted gaiety permeating this portrait is quite exceptional in Modigliani's production. This Parisian prostitute— possibly one of many who fell for the handsome Amedeo—is, with her lively, amused eyes, her flared nostrils, and the sneer through her makeup, incompatible with the elusive, melancholic air that tinges most of his portraits.*

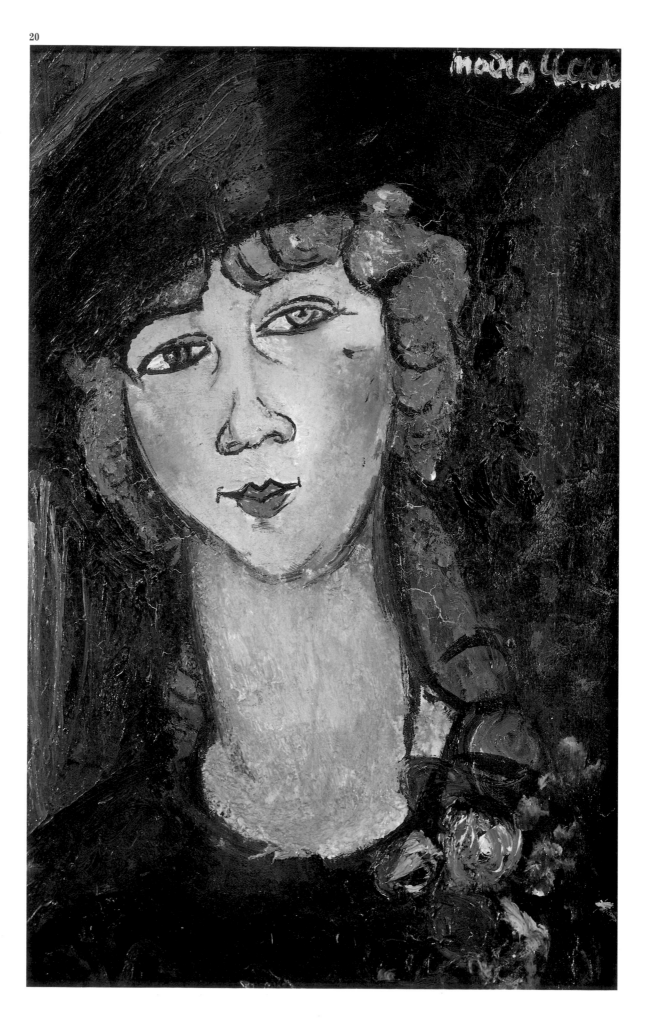

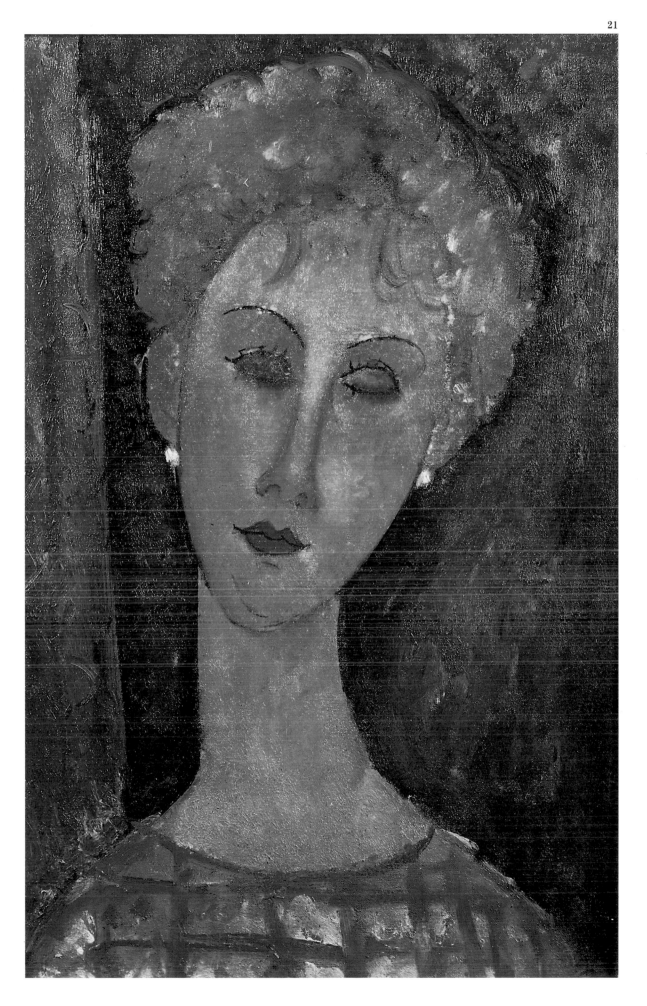

21 Head of a Woman
with Earrings, *1917. The
distortion evident in
Modigliani's figures is less
suited to the vulgar charm
of Lolotte (plate 20) than
to the languorous air of
refinement emanating
from this portrait, in
which the bluish sockets
of the model's eyes and the
tiny bright dots of her
earrings become the focus
of the viewer's attention.*

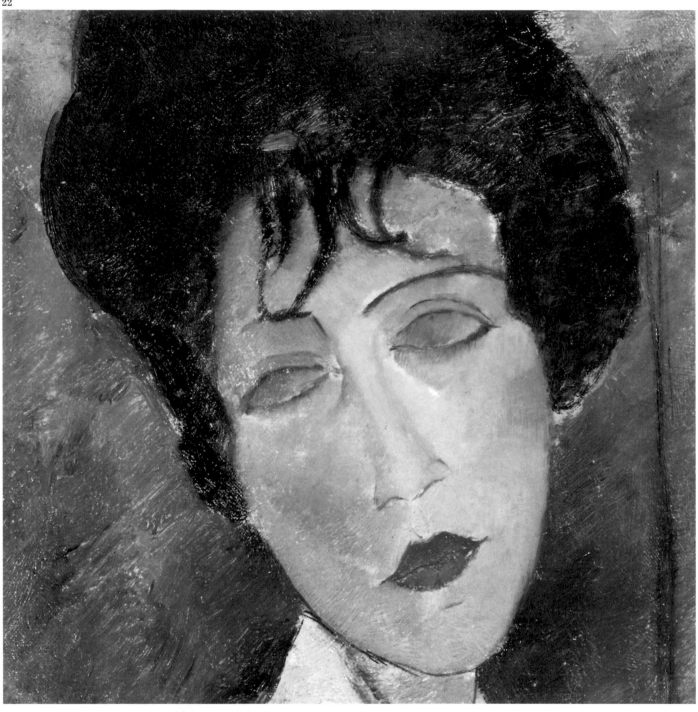

22, 23 Woman in a Black Necktie, *1917. Few other works by Modigliani emanate such a mysterious gaze as strongly as this portrait. The artist explained to Léopold Survage that it was an intensely introspective gaze, one similar to those found in images of the pharaoh Akhenaton or in the Charioteer of Delphi, which so fascinated Modigliani. This effect in painting—achieved in sculpture more readily by the character of the materials—enhances the model's remoteness, inviting the viewer to ponder the viability of communication between human beings. The same question is at the foundation of the metaphysical painting of Giorgio de Chirico, another Italian artist.*

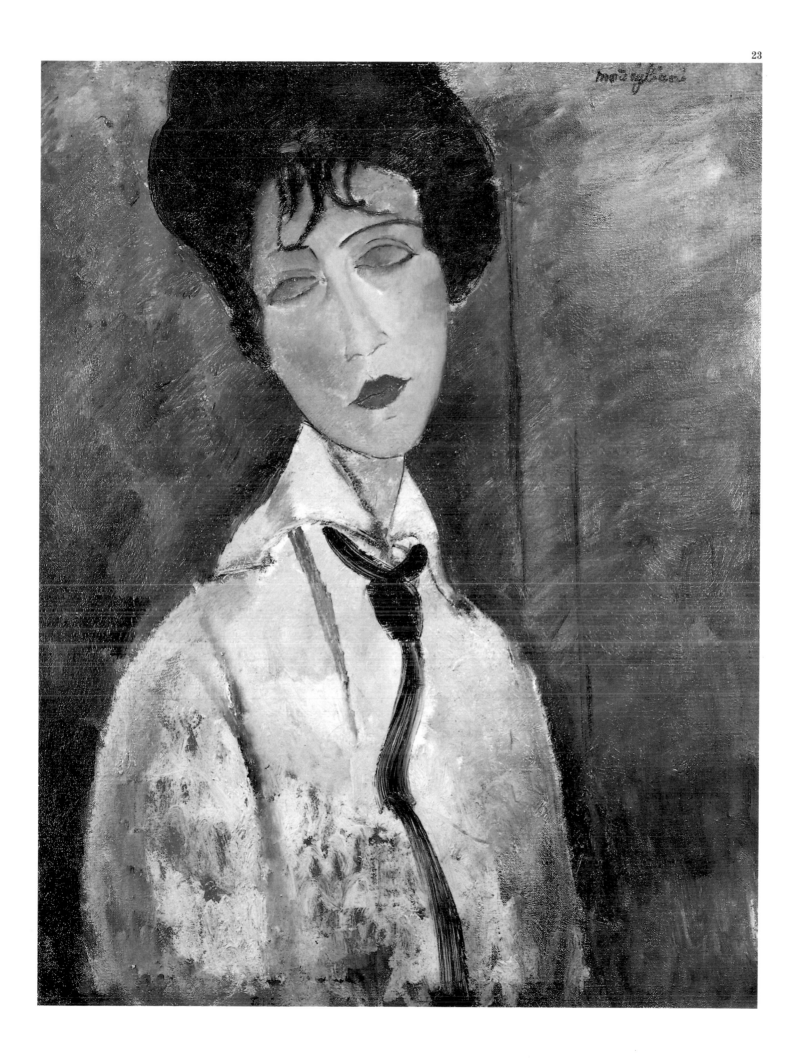

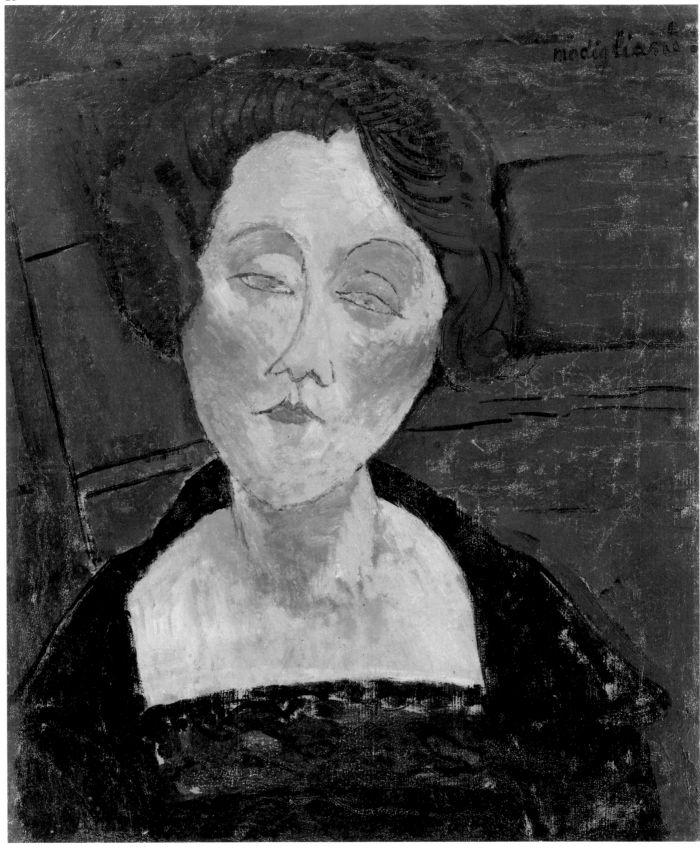

24 Woman with Red Hair and Blue Eyes, *1917. Modigliani was partial to auburn hair and blue eyes, two traits shared by several of his models, including Jeanne Hébuterne and the sitter of this portrait. Here again the viewer's focus is drawn to the eyes, whose serene blue color fills their entire surface. Thanks to his exceptional draftsmanship, the artist was able, with only a few strokes, to imbue the sitter's countenance with great expressivness.*

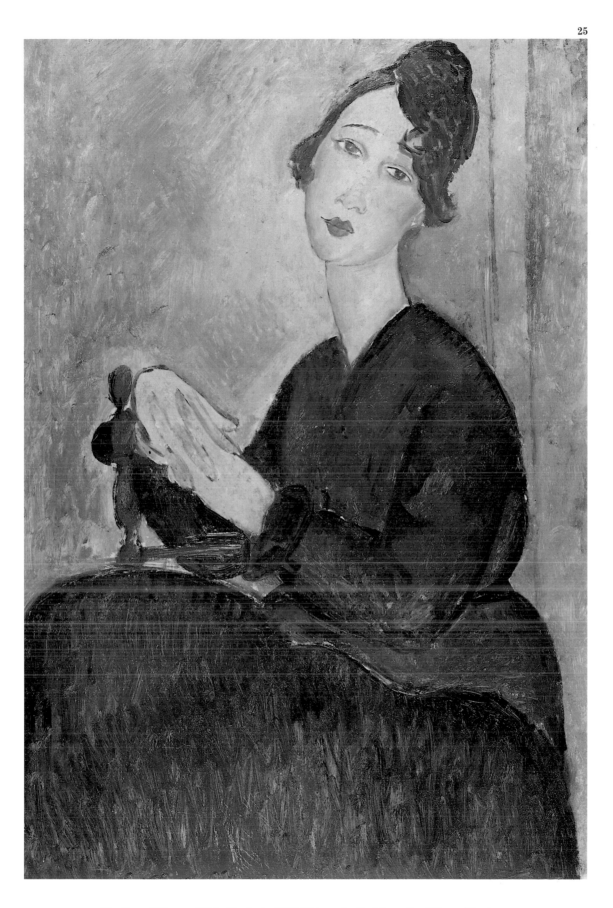

25 Seated Woman (Dédie Hayden), *1918. This portrait of the wife of Henry Hayden—*
a Polish Cubist painter also residing in Paris in those years—is evidence of
Modigliani's dependence on a truthful perception of his models, which prevented him
from painting them from memory.

26, 27 Woman with Blue Eyes, *1918;* Young Girl with Brown Hair, *1918. The neutral backgrounds of these two portraits underscores the tactile value of the sitters' faces. While the art of this period was increasingly dominated by analytic approaches, Modigliani, in keeping with his own traditional view of the painter's role, remained more concerned with the specifically tangible aspects of art.*

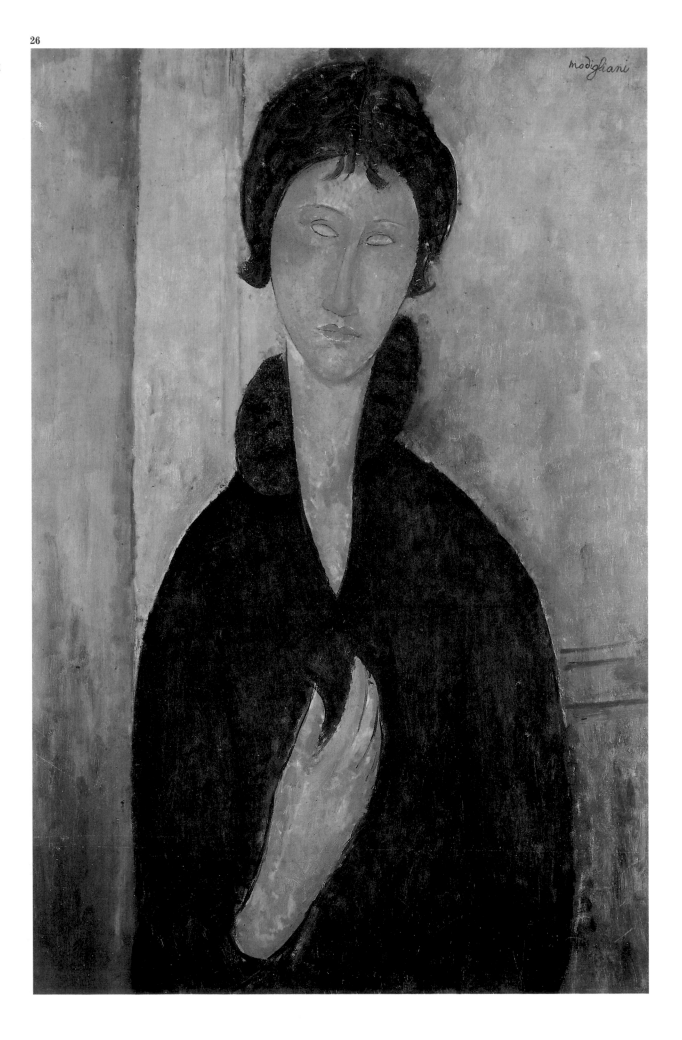

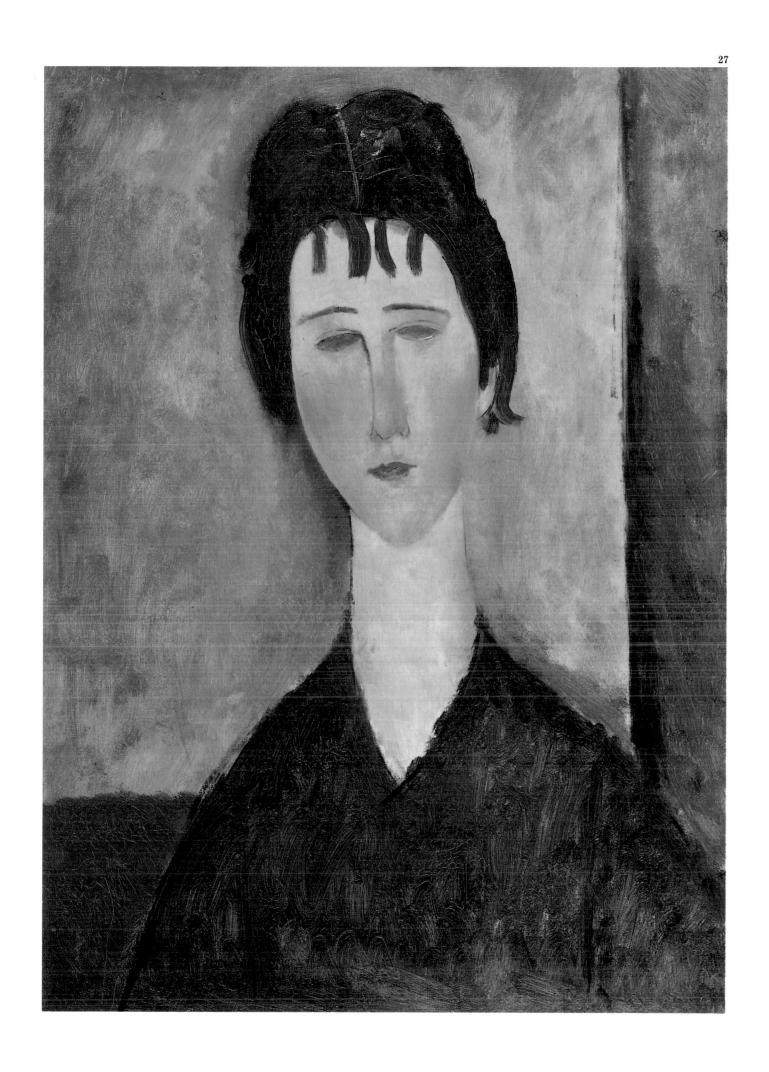

28

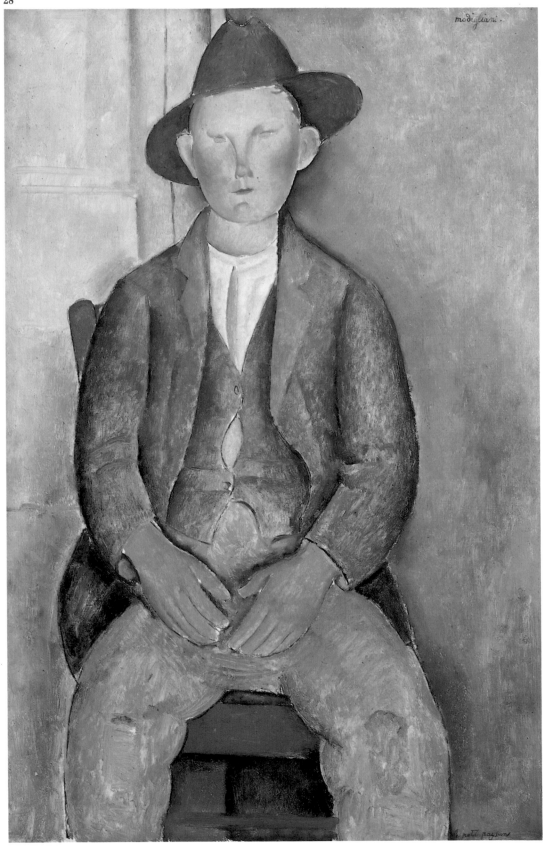

28, 29 The Little Peasant, *1918; Young Peasant Leaning Against a Table, 1918.*
*Modigliani's portraits of children, such as the two shown here, are suffused with a
certain sense of timidity and defenselessness, perhaps foreshadowing the melancholy
that tinges the artist's portrayal of the later stages of life. The models were generally
young apprentice workers, whom the hardships of labor had prematurely forced into
adulthood.*

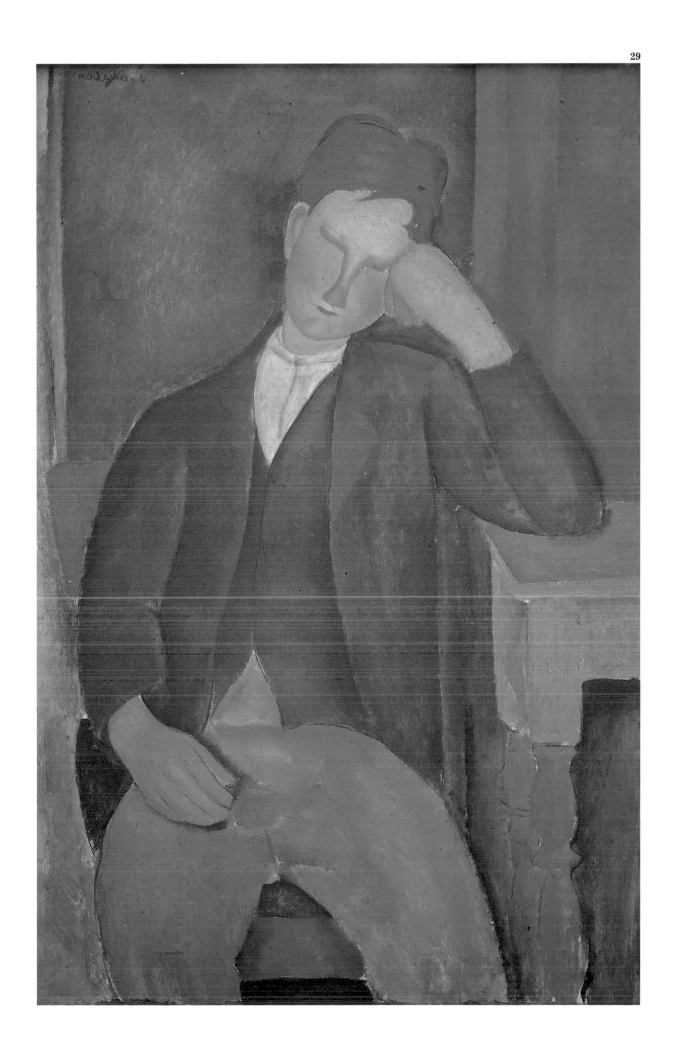

30 Seated Young Woman
with Loose Hair, *1919.*
In this work, the painter
relinquished his traditional
use of black strokes to define
the figure's essential lines,
opting instead to construct
the image out of large fields of
color. The painting carefully
avoids all suggestion of three-
dimensionality, as was
characteristic of Modigliani's
lack of interest in spatial
effects.

30

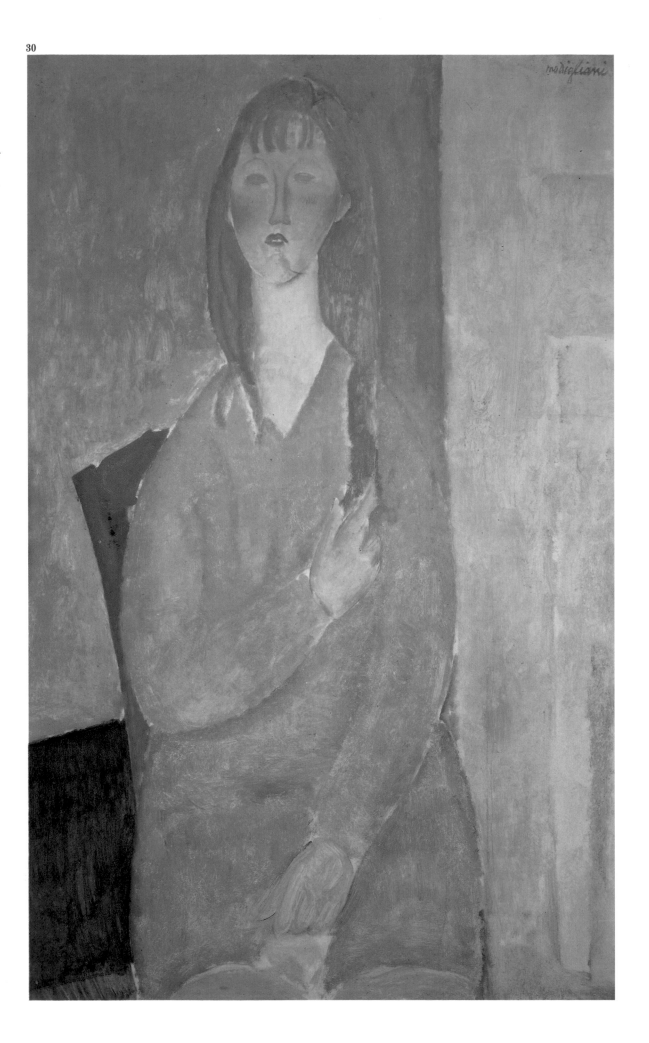

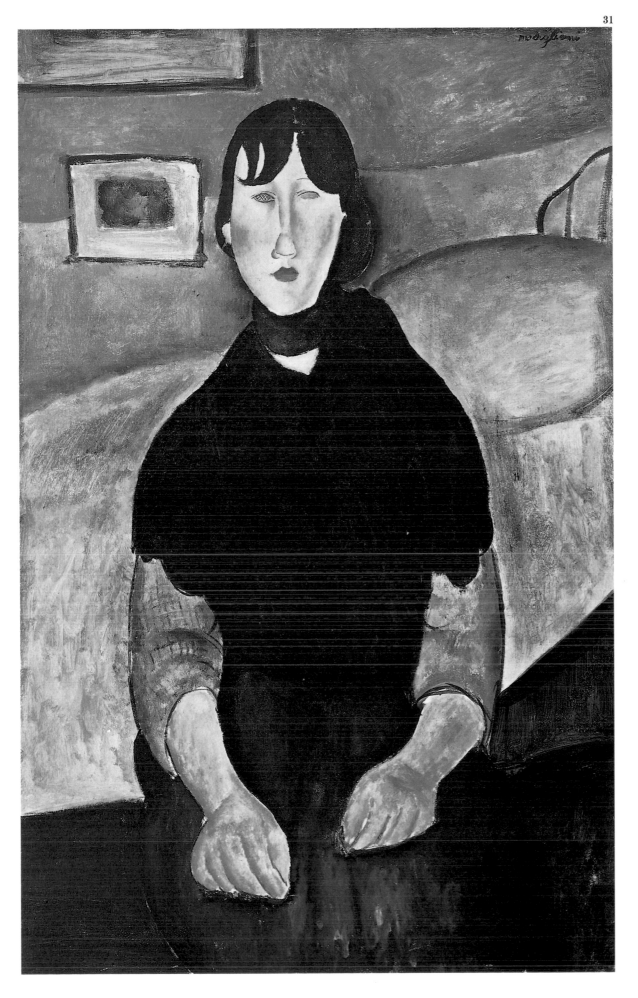

31 The Country Girl, *1919.*
The model of this painting
appears to be Germaine
Lable, the daughter of the
concierge of the building
where Modigliani's friend,
the poet Max Jacob, lived.
The young woman is depicted
seated against a shallow,
nearly abstract background
in which the curved lines of
the bed are echoed by the
sinuous contour of the
wainscoting. The overall
seediness of the scene is
brightened somewhat by the
girl's lively beauty and hardy
laborer's hands.

Nudes

Around 1916 Modigliani renewed his interest in nudes—a subject he had already addressed as a sculptor—and a year later his production was consumed by them. While early on his nudes had been characterized by the rigid stylization typical of African statuary, now they concentrated on genuine displays of sensuality. Unlike his portraits, the faces of these nudes are rendered with just a few simple lines. This shifts the focus of the painting onto the sitter's body, which is modeled by a combination of a sinuous contour traced in dense black strokes and impasto brushwork, producing a strong tactile sensation. Modigliani's distinctive framing of these nudes crops the figure at midthigh, causing the rest of the sensuous body to flood the canvas. Sometimes the model is portrayed in the pose of a "modest Venus," but more often the figure exudes a quiet shamelessness that is also highly erotic. This quality did not go unnoticed by the Parisian police, who ordered the removal of some of the nudes exhibited at Modigliani's first and only one-man show at the Berthe Weill gallery in December 1917. Not just the vivid representation of the models' pubic hair upset the zealous functionaries; they were presumably also outraged by the immorality of the tranquil display of a naked body without an allegorical reference or formal euphemism. Edouard Manet achieved similarly scandalous results a few decades earlier with his *Olympia*.

32

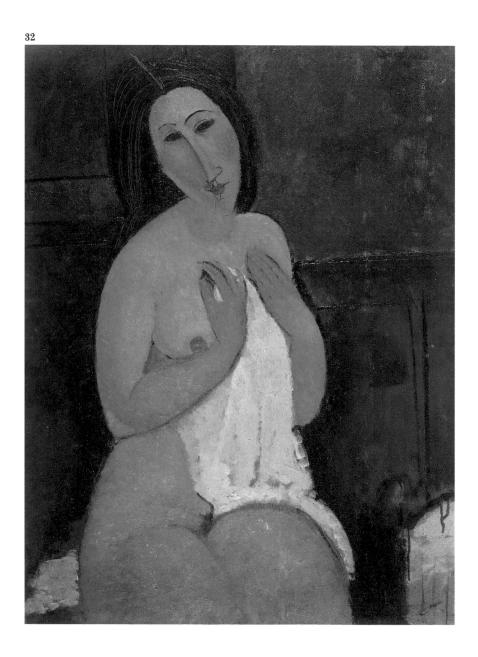

32 Seated Nude with a Shirt in Her Hands, *1917. While Modigliani's reclining nudes display a certain lax indifference, those that are seated exude a more withdrawn attitude, at once modest and somewhat helpless. Modigliani's method did not treat the pictorial surface consistently throughout, so the painstaking application of thick brushwork to flesh contrasts clearly with the more hurried treatment of the hair, which becomes a large black patch, scratched when the paint was still fresh to let the primer show through.*

33 Seated Nude, *1916. This was the first in the series of nudes that characterized Modigliani's output in the years 1916 and 1917. While the use of lines continues to be essential in the artist's work, especially in tracing the figure's contour and in drawing the features of the model's face, these images appear to possess a new quality: a sensuality that is more empathetic in nature, as expressed by the painter's choice of a warmer palette in which the prevailing orange and rose hues occasionally give way to ravishing dashes of violet.*

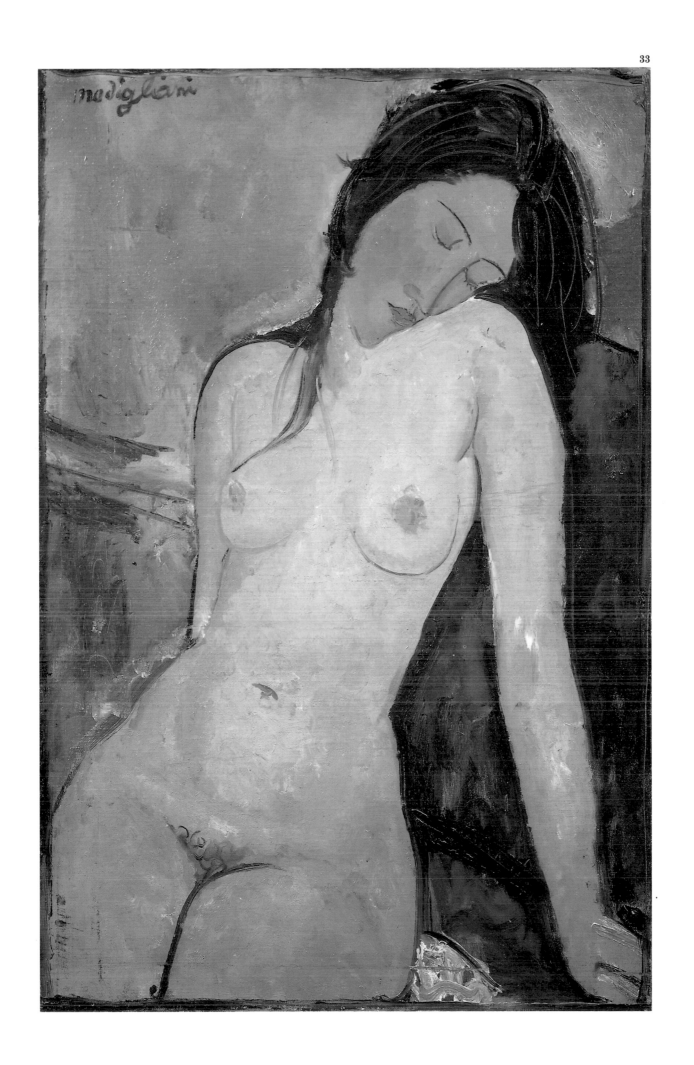

34 Nude on a Cushion, *1917.*
Having left behind the stylized
rigidity of his sculptural phase,
Modigliani revels here in the
opulence of the woman's splendid
figure, inviting the viewer to gaze
on her almost voyeuristically.
To emphasize this effect, he has
framed the image in a peculiarly
fragmentary way, not just cropping
the figure midthigh—a character-
istic feature of Modigliani's nudes—
but also leaving out portions of the
arms and head entirely. The body is
modeled with a painstaking, subtle
brushwork that lingers over a wide
range of warm tonalities, completely
in contrast to the abstract nature of
the bed of pillows, rendered in thick
palpable strokes. The end result is
a contemplative, pacified nude
woman, much in keeping with the
grand tradition of Titian and
Velázquez.

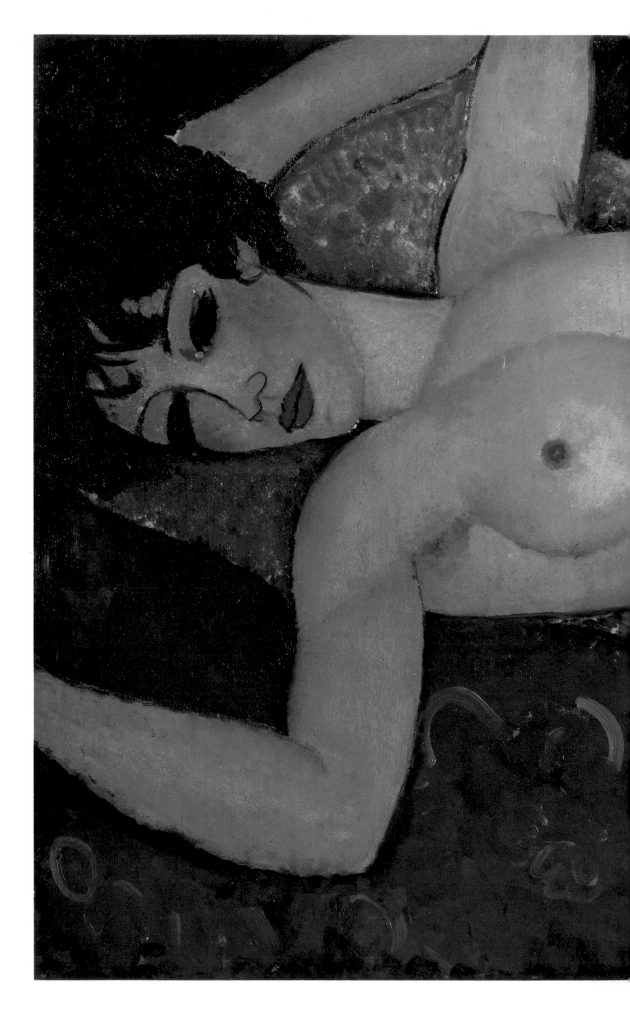

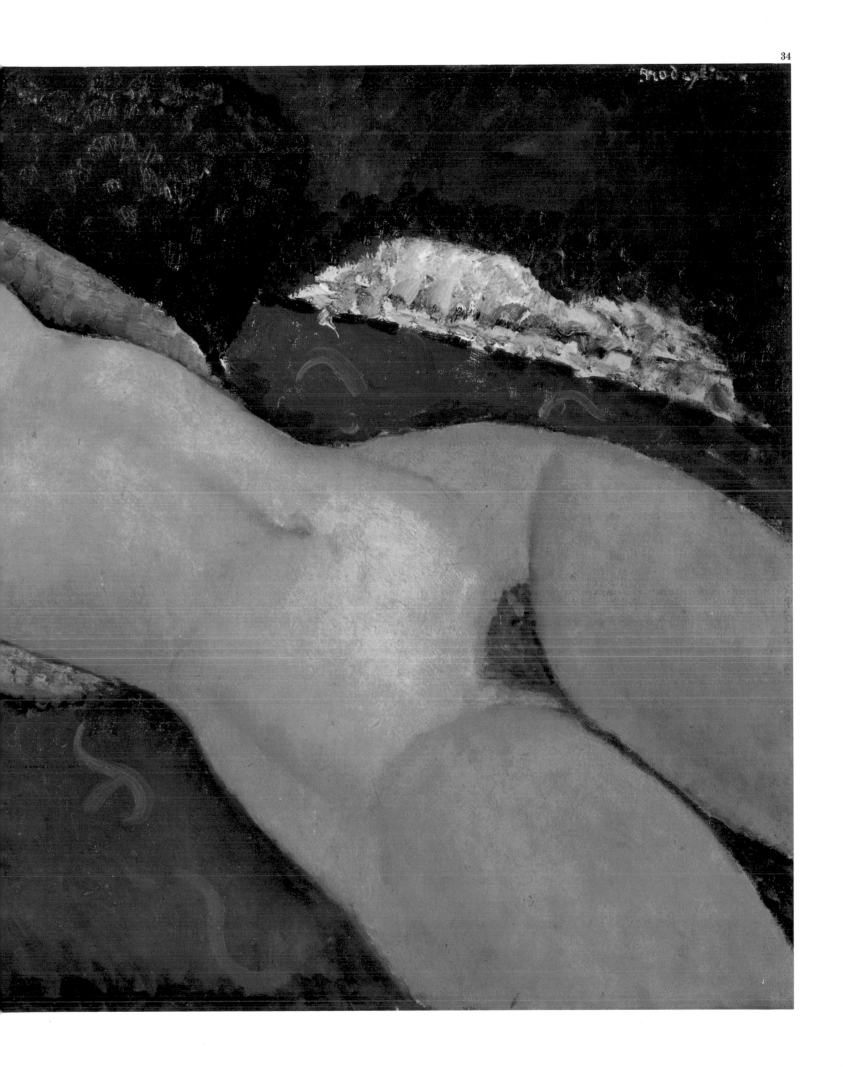

34

43

35 Reclining Nude (*Le Grand Nu*), 1917. In time, Modigliani's nudes became increasingly delicate, losing the solid black outlines and fiery orange hues in favor of a softer harmony of pale tones that melt directly into a background still constructed out of broad brushstrokes. Modigliani thus established himself as one of the great masters of the nude painting, inspiring one of his first patrons, Francis Carco, to state in 1919, "The sometimes soft, animal-like stillness, with its erotic abandon and subtle contentment, have never before found a painter so eager to depict this."

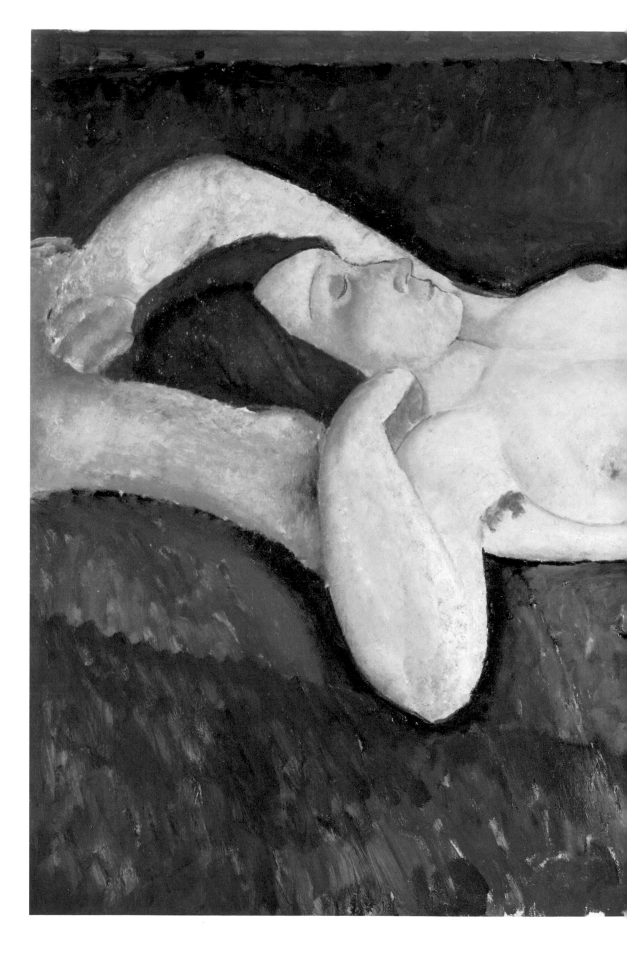

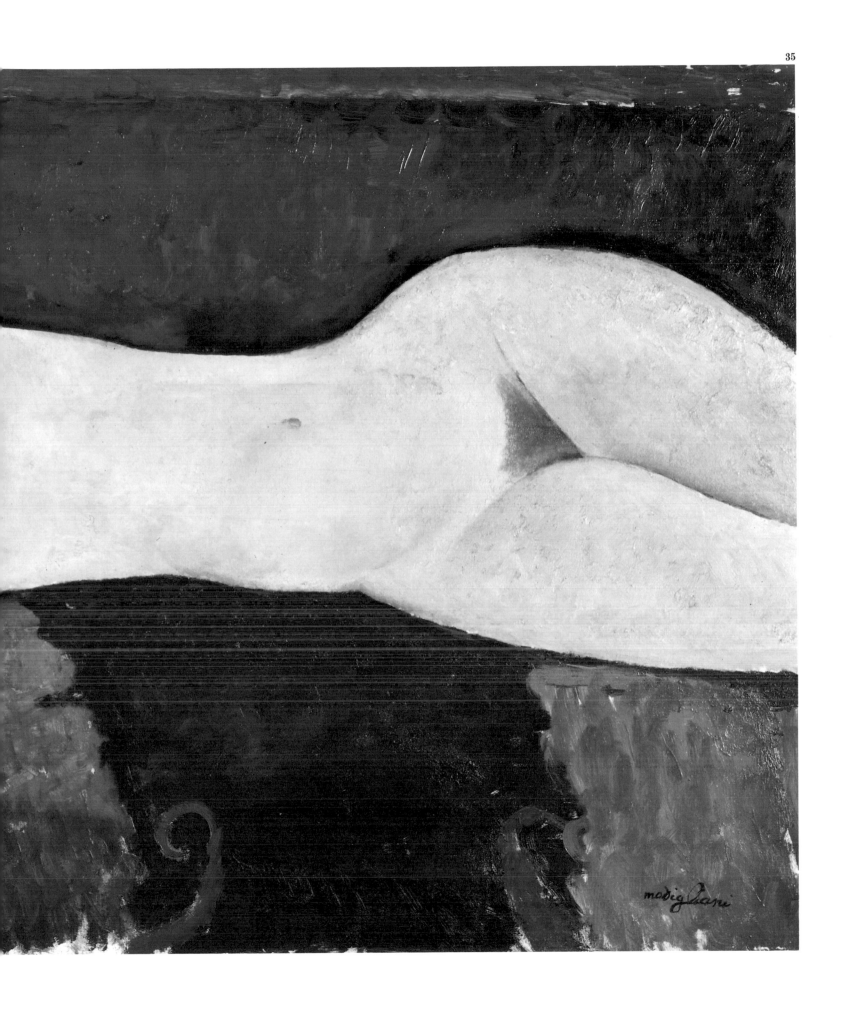

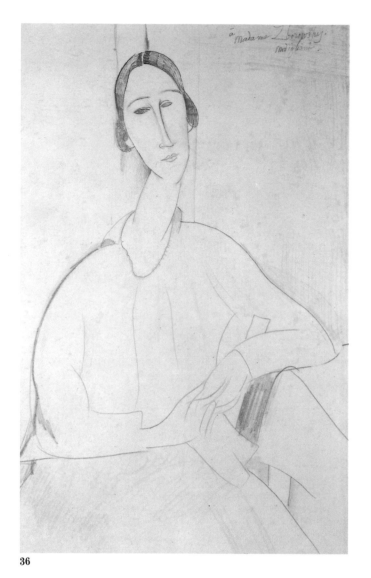

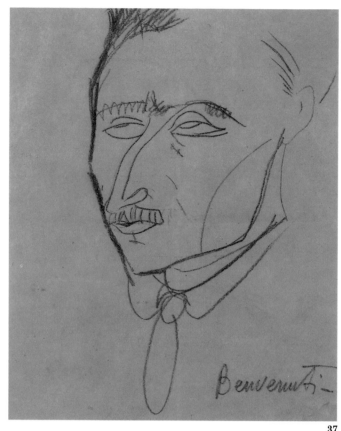

36, 37 Portrait of Hanka Zborowska, *c. 1917;* Portrait of Aristide Sommat, *c. 1918. These two portraits are evidence of Modigliani's excellent draftsmanship. While the former is an unhurried figure study and the latter a swift sketch (one of many he executed on the spot to indulge the request of a friend), both drawings show the same measured strokes made with an economy of resources that exhibit Modigliani's extraordinary dexterity.*

The Parisian Bohemia

Modigliani's inability to pay for models, together with the lack of clients during the harsh years of World War I—when he was finally beginning to gain recognition—explain why the artist's works are populated almost exclusively by men, women, and children from his own circle, most of whom belonged to the artistic bohemia of Paris. Jean Cocteau, one of the painter's acquaintances, aptly described this scene when he said that "in Montparnasse we could afford the luxury of being poor; poverty was fun." Modigliani portrayed each of his fellow bohemians in turn, including Chaïm Soutine, a Lithuanian-born Jew who was destitute but had boundless admiration for the Italian artist; Beatrice Hastings, a writer who worked for a British magazine and had a tempestuous love affair with Modigliani; the poet Leopold Zborowski and his wife Hanka, who started out as commercial advisors to Modigliani and eventually became his caretakers when he fell ill; and, above all, Jeanne Hébuterne, the artist's last great love, who gave up everything to follow her unstable—and occasionally unfaithful—companion even into death. The relationship that bound all of these figures to Modigliani was summed up in a tribute by the poet Max Jacob: "Like an aristocrat, you led a life of simple grandeur. We love you."

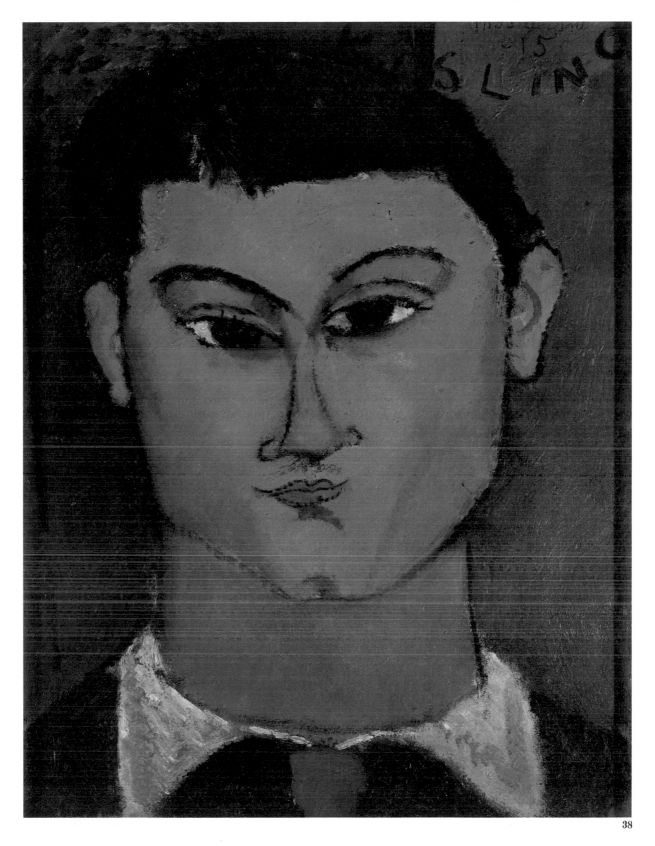

38

38 Head of Kisling, *1915. The Polish-born Moïse Kisling was one of Modigliani's closest friends. Both artists were Jewish, and both had left their respective countries to live abroad. An extroverted and generous painter given to unbridled, boisterous acts of revelry, he enjoyed a recognition that Modigliani never experienced during his lifetime. Kisling's liveliness and joie de vivre are clearly conveyed in this portrait by his angular features and prominent jaw, elements that also attest the extent to which Cubist aesthetics were influencing the work of the Italian artist in those years.*

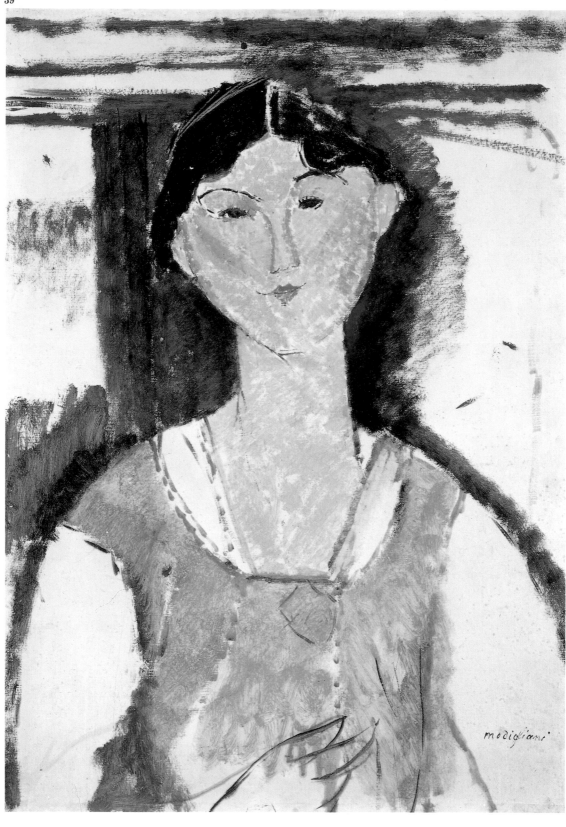

39 Portrait of Beatrice Hastings, *1915. This is one of a number of portraits Modigliani made of the British journalist from South Africa with whom he had a passionate affair, but the frail, delicate image in no way corresponds to the description of Beatrice given by her contemporaries.*

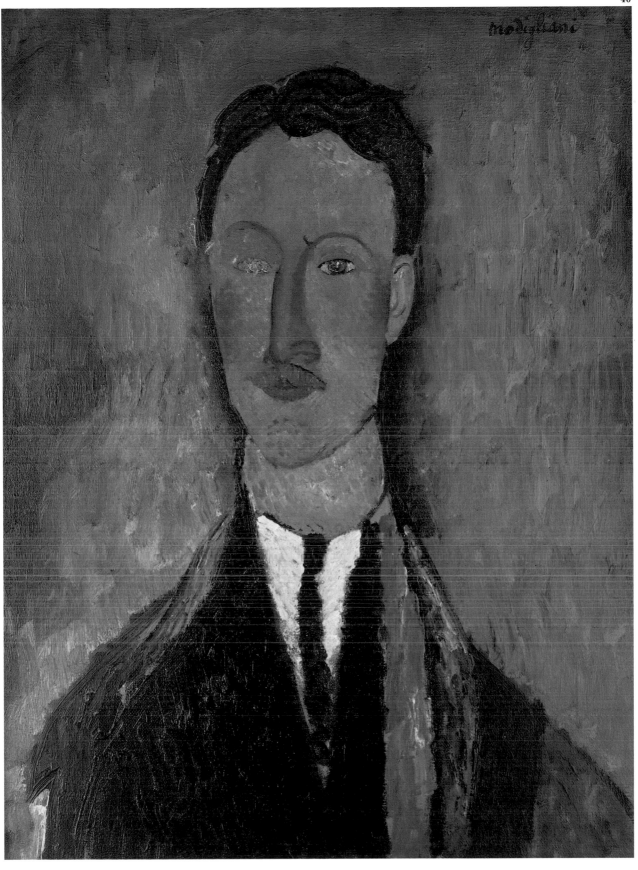
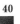

40 Portrait of Léopold Survage, *c. 1917. Survage, a painter and set designer with Cubist inclinations, shared both a studio with Modigliani and his alcoholic excesses, especially during their sojourn in Nice in 1918. Modigliani justified giving the sitter only one "normal" eye by explaining, "With one eye you are looking at the outside world, while with the other you are looking within yourself."*

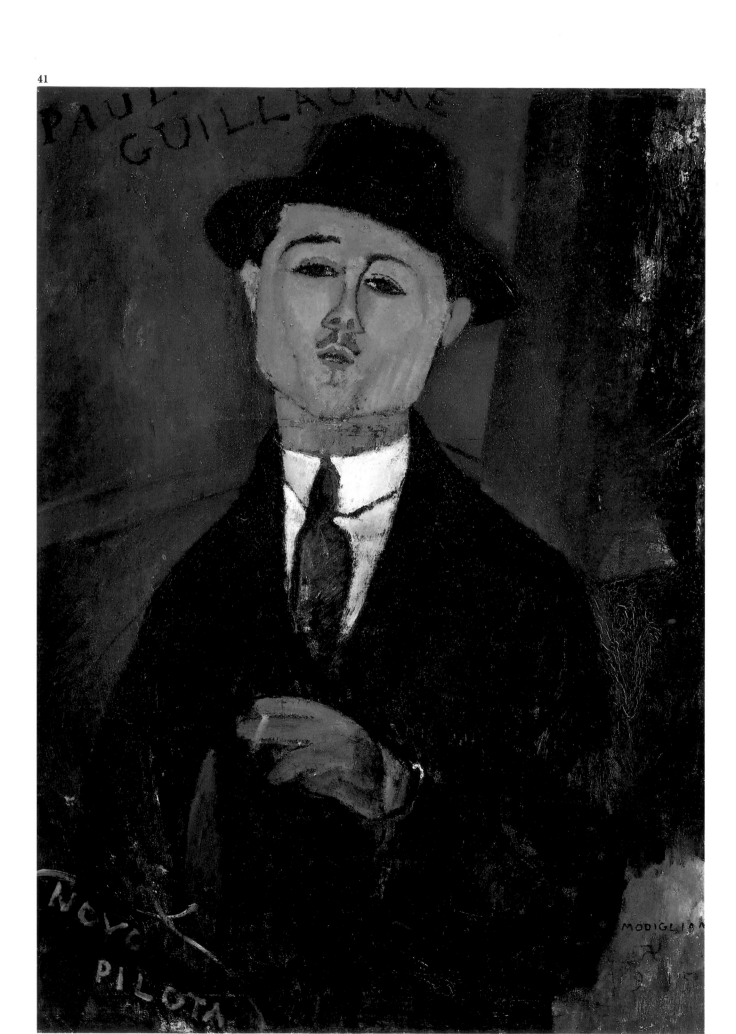

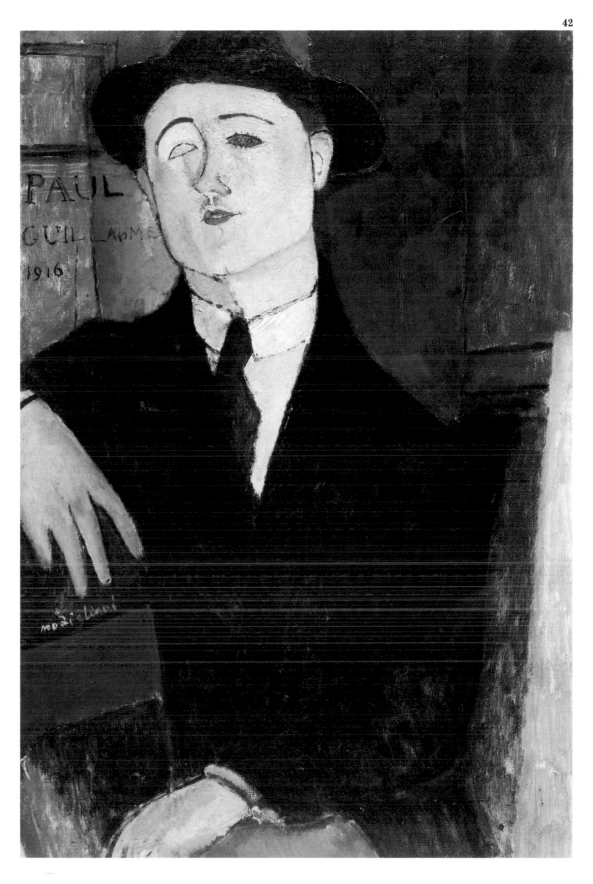

41, 42 Paul Guillaume, "Novo Pilota", *1915; Portrait of Paul Guillaume, 1916. Between
1914 and 1917, Guillaume was in effect virtually the sole client who held enough trust
and interest in Modigliani to purchase any of his works. The angularity of the sitter's
features is characteristic of the artist's receptiveness to Cubist influences at this stage.
Two inscriptions in the first of these portraits—"Stella Maris" and "Novo Pilota"—are
the painter's homage to his benefactor, whose role is thus elevated to leader of an entire
new generation of artists.*

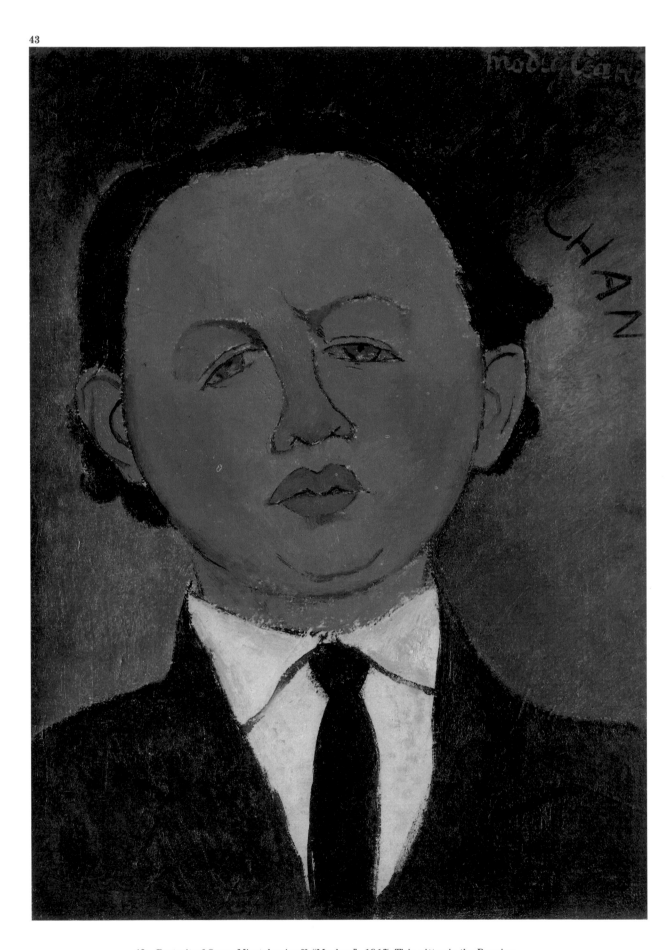

43 Portrait of Oscar Miestchaninoff, "Mechan", *1917. This sitter is the Russian sculptor Oscar Miestchaninoff, whom the Italian artist familiarly called "Mechan." Unlike the typical elongated figures of Modigliani's other paintings, Miestchaninoff's dull and disgusted expression is inscribed in a nearly perfect circumference.*

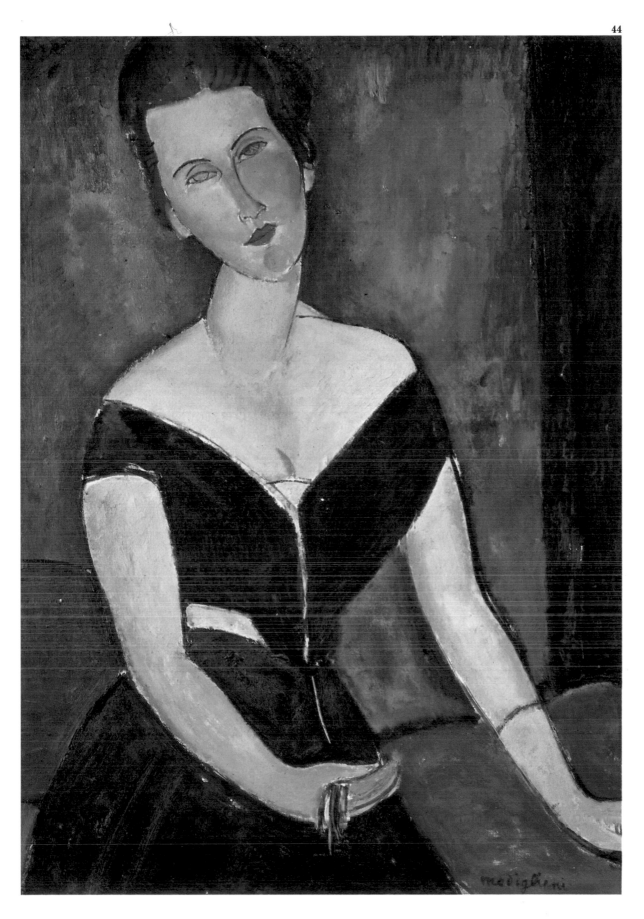

44 Portrait of Madame Georges van Muyden, *1917. This is quite possibly one of a small number of portraits Modigliani painted as a commission, since his models generally belonged to his circle of fellow bohemians. These circumstances account for the more composed, elegant, and self-possessed nature of the sitter.*

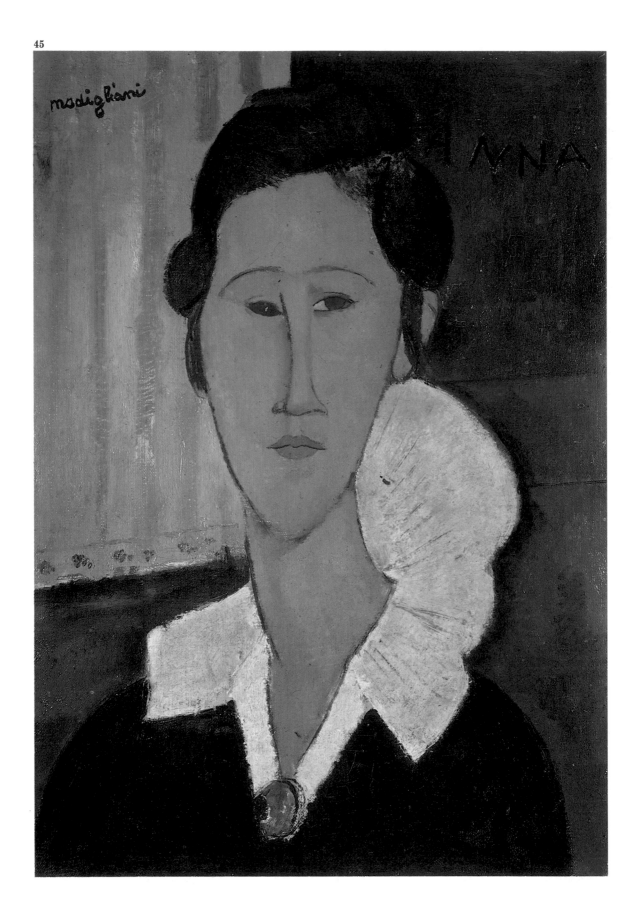

45 Portrait of Madame Hanka Zborowska, *1917. This is one of the earliest in a long series of portraits that Modigliani painted of the wife of Leopold Zborowski. The Cubist influence is unmistakable in the asymmetrical treatment of the model's features and in the peculiar representation of the fanned-out collar of her blouse.*

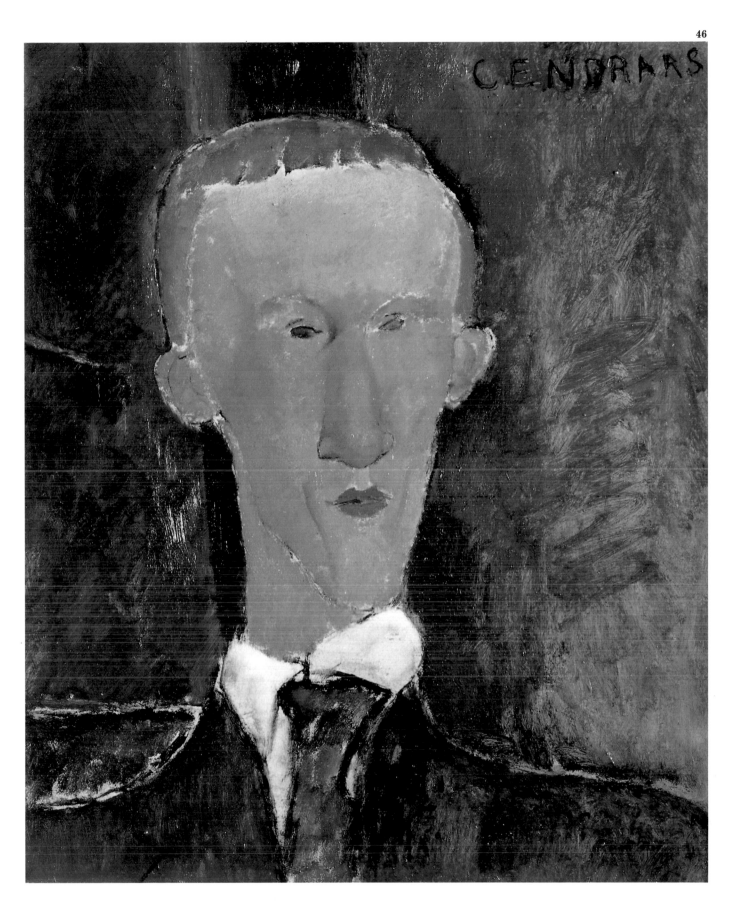

46 Portrait of Blaise Cendrars, *1917. Modigliani painted this portrait of Cendrars shortly after the latter had returned from the war with a wound that resulted in his arm being amputated. On the occasion of the exhibition of the painter's works at the Berthe Weill gallery in 1917, Cendrars wrote an introductory text entitled "On a Portrait by Modigliani: The Inner World / The Human Heart with / Its 17 Movements / In the Spirit / And the Ups and Downs of Passion."*

47, 48 Portrait of Lunia Czechowska, *1917*; Portrait of Jeanne Hébuterne in a Straw Hat, *1917. Here are two women of vastly different temperaments whose presence played a crucial role in the artist's final years after his tempestuous involvement with Beatrice Hastings. While Jeanne was the submissive companion, able to endure her lover's excesses, Lunia proved the more mature and experienced woman, ultimately becoming his closest friend and confidante. Her relationship with Modigliani was always of a platonic nature, which is surprising given the painter's promiscuous habits.*

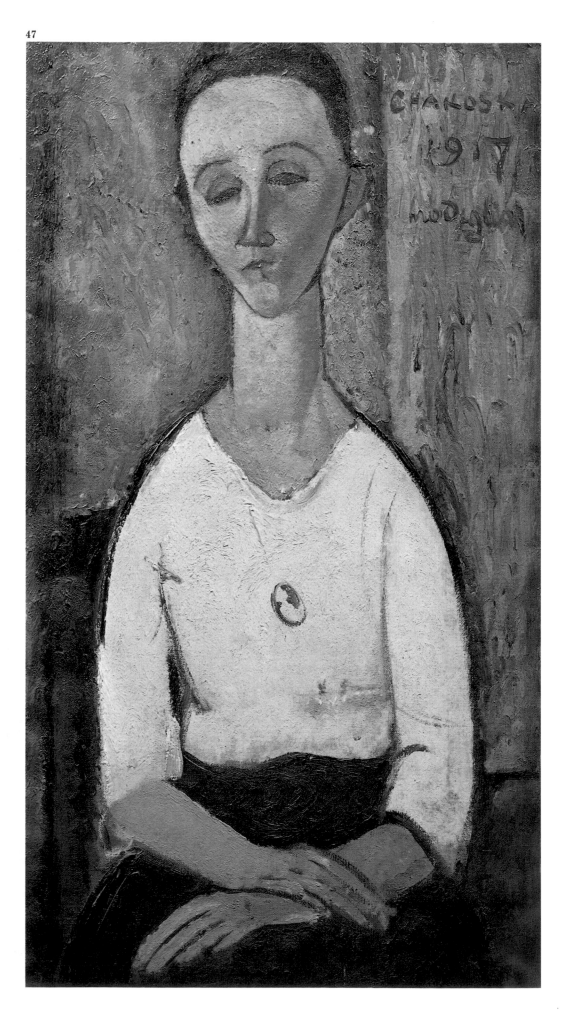

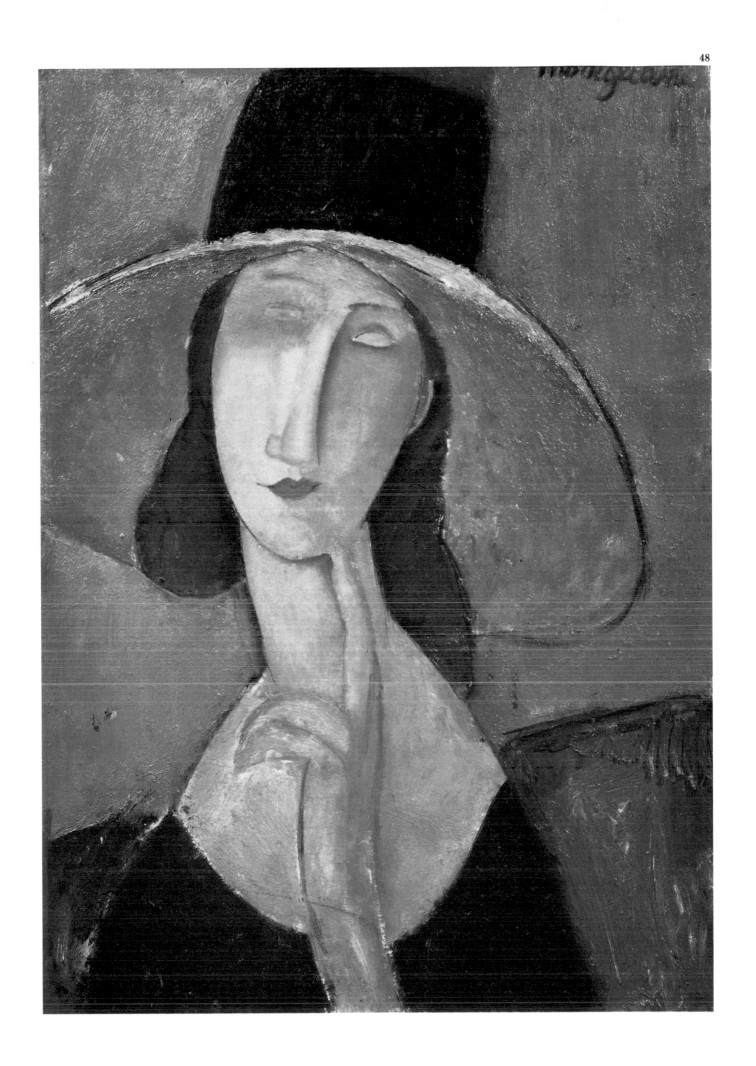

48

57

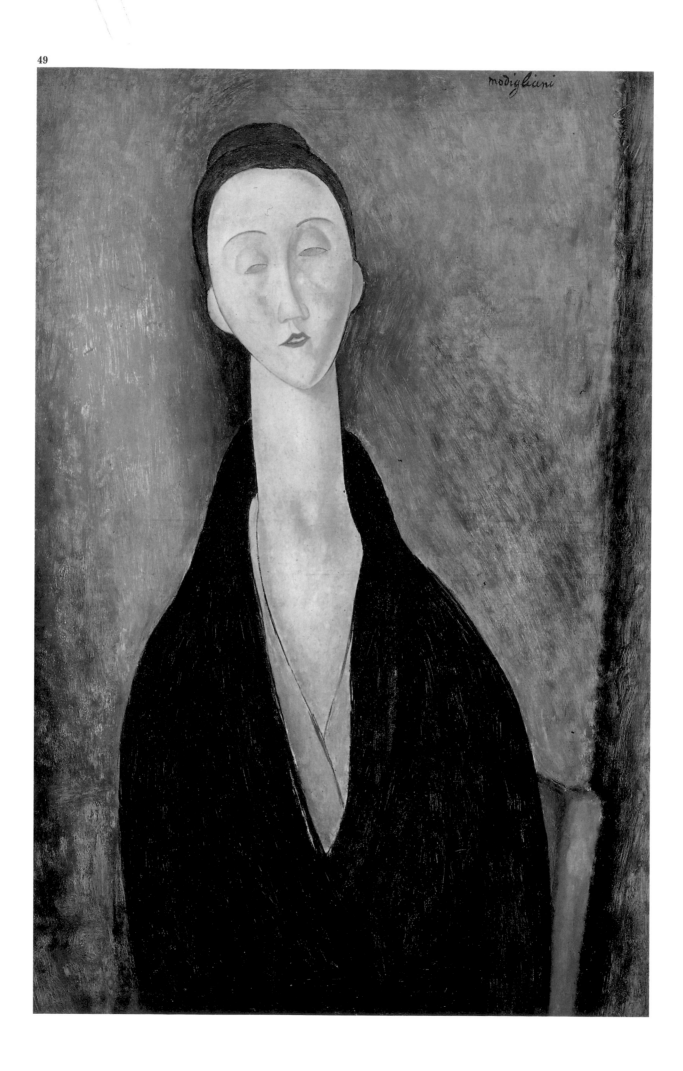

modigliani

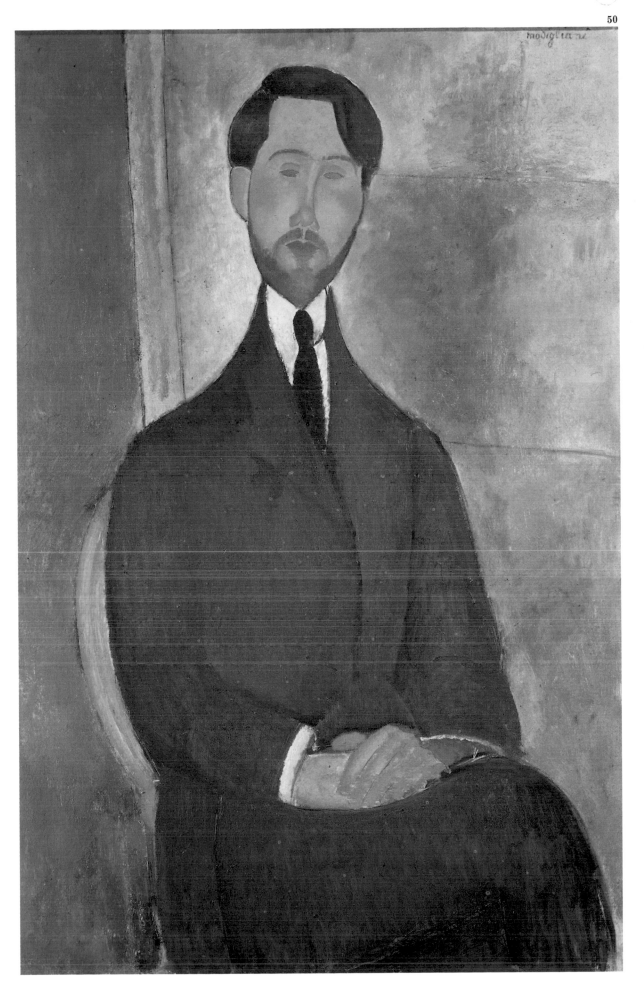

49, 50 Madame Zborowska, *1918;* Portrait of Leopold Zborowski, *1919. In 1916, the encounter between Modigliani and Leopold Zborowski marked a turning point in both of their lives. The painter found not only a dealer who was profoundly committed to his work, but also a friend and a benefactor. For his part, the Polish poet decided to give up literature and, driven by his obsession for Modigliani's work, immersed himself completely in the dealings of the art market. Their relationship, marked by the Zborowskis' tireless devotion to protecting the artist from his own intemperance, ended only with the latter's death.*

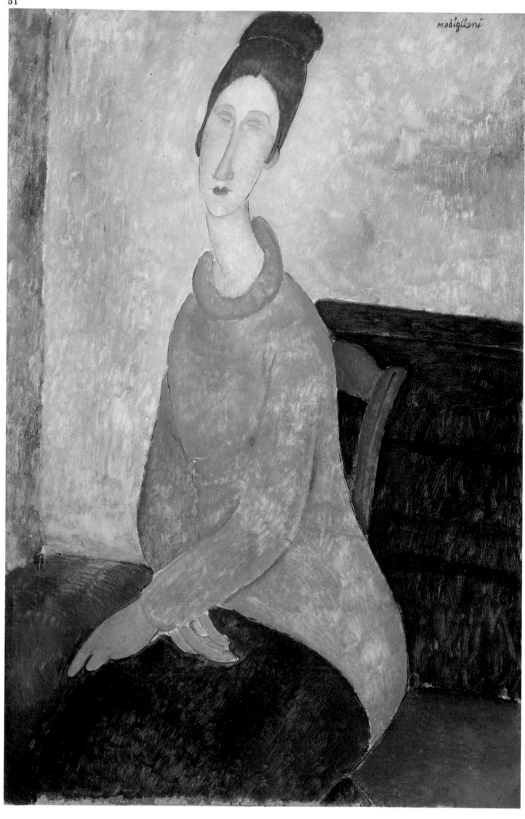

51 Yellow Sweater (Portrait of Mademoiselle Hébuterne), *c. 1919. Modigliani's friends described his last companion as a talented young artist who, in her lover's presence, always remained imperturbably silent, to the extent that some of those who met her claimed that they never heard her voice. This image of Jeanne Hébuterne—whom her friends used to call "Coconut" for her peculiar auburn hairdo—effectively conveys her gentle and somewhat languorous demeanor. The composition is divided into broad fields of color in a subtly decorative manner; the figure's sinuous silhouette stands out uninterrupted against the background.*

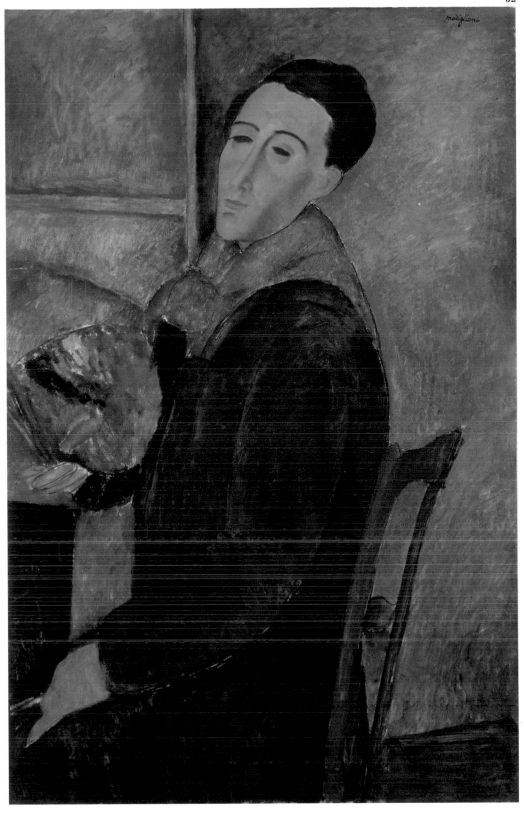

52 Self-Portrait, *1919. In what was to be one of his last works, the specter of death seems to hover over the artist in his only self-portrait. Haggard, wasted by disease and overindulgence, Modigliani appears to be pondering the significance of his own métier as a painter. The end fast approaching, the artist portrayed himself with the same vacant eyes and introspective gaze found in his other paintings, trapping himself and his figures in a similar state of melancholic detachment.*

List of Plates

1 Seated Caryatid, c. 1911. Pencil on paper. Private collection, Milan

2 Caryatid, c. 1911. Pastel, watercolor, and pencil on paper, 20⅞ × 17″ (53 × 43.8 cm). Musée d'Art Moderne de la Ville de Paris, Paris

3 Rose Caryatid with a Blue Border, c. 1913. Watercolor. Perls Galleries, New York

4 Head of a Woman, c. 1911–12. Sculpture. Perls Galleries, New York

5 Head, c. 1914. Sculpture, 22⅞ × 4¾″ (58 × 12 cm). Musée National d'Art Moderne, Centre Georges Pompidou, Paris

6 Caryatid, c. 1913–14. Gouache. Perls Galleries, New York

7 Caryatid, c. 1913–14. Gouache. Musée National d'Art Moderne, Centre Georges Pompidou, Paris

8 Portrait of Frank Burty Haviland, 1914. Oil on cardboard, 28¾ × 23⅝″ (73 × 60 cm). Collection Gianni Mattioli, Milan

9 Preliminary Study for the Portrait of Diego Rivera, 1914. Oil on canvas, 39⅜ × 31⅛″ (100 × 79 cm). Museu de Arte, São Paulo, Brazil

10 Antonia, 1915. Oil on canvas, 32¼ × 18⅛″ (82 × 46 cm). Musée de l'Orangerie, Paris

11 Head of a Young Woman, 1915. Oil on paper, 21¼ × 16½″ (54 × 42 cm). Musée National d'Art Moderne, Centre Georges Pompidou, Paris

12 Head of Woman with a Velvet Ribbon, 1915. Oil on canvas, 22 × 18½″ (56 × 47 cm). Musée de l'Orangerie, Paris

13 The Fat Child (L'Enfant Gras), 1915. Oil on canvas, 18½ × 15″ (55 × 46 cm). Collection Vitali, Milan

14 Head of a Woman, 1915. Oil on canvas, 18⅛ × 15″ (46 × 38 cm). Pinacoteca di Brera, Milan

15 Louise, 1915. Oil on paper, 19⅝ × 14⅝″ (50 × 37 cm). Collection Mazzotta, Milan

16 The Servant, 1916. Oil on canvas, 28¾ × 21¼″ (73 × 54 cm). Kunsthaus Museum, Zurich

17 Portrait of a Young Woman (Victoria), 1916. Oil on canvas, 31⅞ × 23⅝″ (81 × 60 cm). The Tate Gallery, London

18 Man in a Hat, 1916. Oil on canvas, 32⅝ × 17¾″ (83 × 45 cm). Collection Emilio Jesi, Milan

19 The Blonde Renée, 1916. Oil on canvas, 24 × 15″ (61 × 38 cm). Museu de Arte, São Paulo, Brazil

20 Head of a Woman in a Hat (Lolotte), c. 1916. Oil on canvas, 21⅝ × 13¾″ (55 × 38 cm). Musée National d'Art Moderne, Centre Georges Pompidou, Paris

21 Head of a Woman with Earrings, 1917. Oil on canvas, 18⅛ × 11¾″ (46 × 30 cm). Musée National d'Art Moderne, Centre Georges Pompidou, Paris

22, 23 Woman in a Black Necktie, 1917. Oil on canvas, 25⅝ × 19⅝″ (65 × 50 cm). Private collection, Paris

24 Woman with Red Hair and Blue Eyes, 1917. Oil on canvas, 21⅝ × 18⅛″ (55 × 46 cm). Private collection, Turin

25 Seated Woman (Dédie Hayden), 1918. Oil on canvas, 36¼ × 23⅝″ (92 × 60 cm). Musée National d'Art Moderne, Centre Georges Pompidou, Paris

26 Woman with Blue Eyes, 1918. Oil on canvas, 31⅞ × 21¼″ (81 × 54 cm). Musée National d'Art Moderne, Centre Georges Pompidou, Paris

27 Young Girl with Brown Hair, 1918. Oil on canvas, 26 × 18″ (66 × 45.7 cm). Collection Emilio Jesi, Milan

28 The Little Peasant, 1918. Oil on canvas, 39⅜ × 25⅜″ (100 × 65 cm). The Tate Gallery, London

29 Young Peasant Leaning Against a Table, 1918. Oil on canvas, 39⅜ × 25⅝″ (100 × 65 cm). Musée de l'Orangerie, Paris

30 Seated Young Woman with Loose Hair, 1919. Oil on canvas, 45⅝ × 28¾″ (116 × 73 cm). Private collection

31 The Country Girl, 1919. Oil on canvas, 40⅛ × 25⅝″ (102 × 65 cm). Private collection, Paris

32 Seated Nude with a Shirt in Her Hands, 1917. Oil on canvas, 36¼ × 26⅝″ (92 × 60 cm). Private collection, Roubaix

33 Seated Nude, 1916. Oil on canvas, 36¼ × 23⅝″ (92 × 60 cm). The Courtauld Institute of Art, London

34 Nude on a Cushion, 1917. Oil on canvas, 23⅝ × 36¼″ (60 × 92 cm). Collection Gianni Mattioli, Milan

35 Reclining Nude (Le Grand Nu), c. 1919. Oil on canvas, 28¾ × 45⅝″ (73 × 116 cm). The Museum of Modern Art, New York

36 Portrait of Hanka Zborowska, c. 1917. Pencil, 13⅜ × 9½″ (34 × 24 cm). Private collection

37 Portrait of Aristide Sommat, c. 1918. Charcoal. Museo Civico Giovanni Fattori, Livorno

38 Head of Kisling, 1915. Oil on canvas, 14⅝ × 11″ (37 × 28 cm). Pinacoteca di Brera, Milan

39 Portrait of Beatrice Hastings, 1915. Oil on canvas, 27⅛ × 19¼″ (69 × 49 cm). Collection Mazzotta, Milan

40 Portrait of Léopold Survage, c. 1917. Oil on canvas, 24 × 18⅛″ (61 × 46 cm). The Art of the Ateneum, Helsinki

41 Paul Guillaume, "Novo Pilota", 1915. Oil on canvas, 41⅜ × 29½″ (105 × 75 cm). Musée de l'Orangerie, Paris

42 Portrait of Paul Guillaume, 1916. Oil on canvas, 31⅞ × 21¼″ (81 × 54 cm). Civica Galleria d'Arte Moderna, Milan

43 Portrait of Oscar Miestchaninoff, "Mechan", 1917. Oil on canvas, 18⅛ × 13″ (46 × 33 cm). Perls Galleries, New York

44 Portrait of Madame Georges van Muyden, 1917. Oil on canvas, 36¼ × 25⅝″ (92 × 65 cm). Museu de Arte, São Paulo, Brazil

45 Portrait of Madame Hanka Zborowska, 1917. Oil on canvas, 21⅝ × 13″ (55 × 33 cm). Galleria Nazionale d'Arte Moderna, Rome

46 Portrait of Blaise Cendrars, 1917. Oil on canvas, 24 × 19⅝″ (61 × 50 cm). Private collection, Rome

47 Portrait of Lunia Czechowska, 1917. Oil on canvas, 31⅞ × 17¾″ (81 × 45 cm). Museu de Arte, São Paulo, Brazil

48 Portrait of Jeanne Hébuterne in a Straw Hat, 1917. Oil on canvas, 21⅝ × 15″ (55 × 38 cm). Collection Lehman, New York

49 Madame Zborowska, 1918. Oil on canvas. Museu de Arte, São Paulo, Brazil

50 Portrait of Léopold Zborowski, 1919. Oil on canvas, 39⅜ × 25⅝″ (100 × 65 cm). Museu de Arte, São Paulo, Brazil

51 Yellow Sweater (Portrait of Mademoiselle Hébuterne), c. 1919. Oil on canvas, 39⅜ × 25⅝″ (100 × 65 cm). The Solomon R. Guggenheim Museum, New York

52 Self-Portrait, 1919. Oil on canvas, 39⅜ × 25⅝″ (100 × 65 cm). Museu de Arte, São Paulo, Brazil

Series Coordinator, English-language edition: Ellen Rosefsky Cohen
Editor, English-language edition: Amy L. Vinchesi
Designer, English-language edition: Judith Michael

Library of Congress Catalog Card Number: 97–70937
ISBN 0–8109–4651–3

Printed and bound in Spain by E. P. Salesianas, Barcelona
Dep. Leg.: B. 15.351 – 1997